PEGASUS
Library

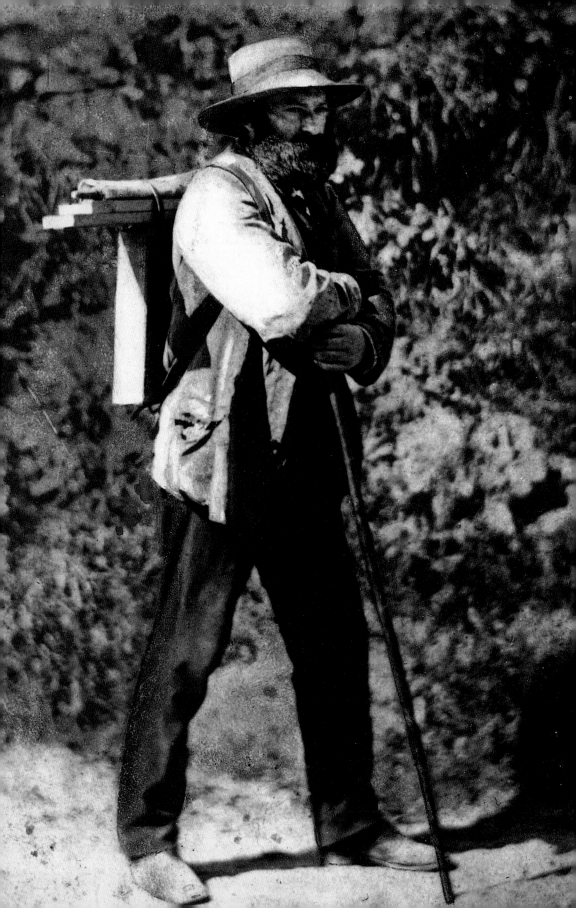

Evmarie Schmitt

Cézanne
in Provence

Prestel

Munich · London · New York

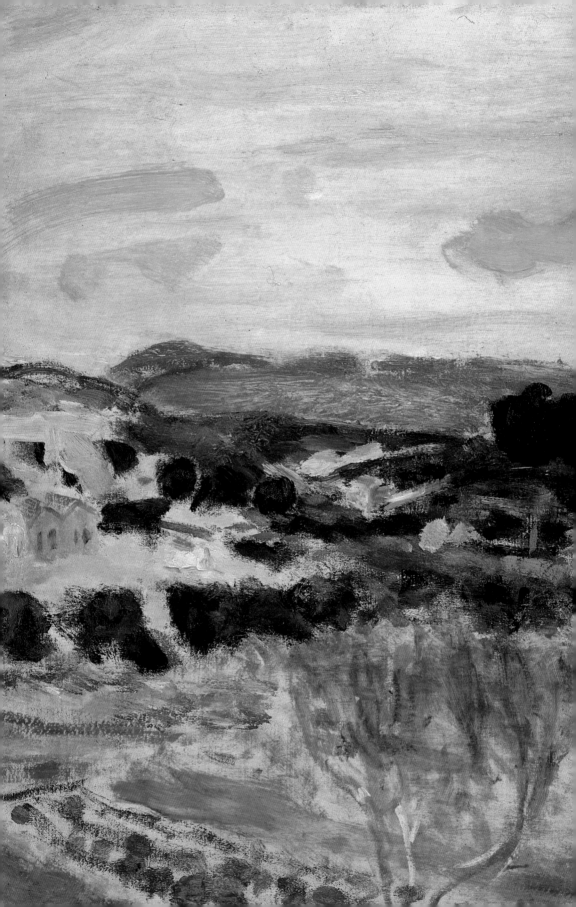

Contents

The Spirit of Provence

The spirit of Provence slumbers under the olive trees; the vigorous countryside embraces it, the odor of the pines exhales it, the sun celebrates it Yet one day I found this spirit, which is scattered pell-mell in a thousand hidden places in the red earth, the cliffs, the luminous pines, the plains and the hills—one day I suddenly discovered it as I was looking at the paintings of Cézanne. It sprung from them puissant and whole, in its unique splendor, which is at once rural and mystical, for the spirit reigns in superb reality over the entire oeuvre of this painter dedicated to lucidity.

The Provençal soul . . . its faith . . . are also communicated to us by Paul Cézanne, who initiates us into his observations, and who reveals this soul and this faith to us in the kind of divine illumination with which his landscapes are suffused. The tortured or tranquil shapes of the rocks, the red blood which he lets passionately flow over the parched soil, the heavy masses of the horizons, the flaming sea, the reveries of the rivers, the gentleness and innocence of the lines which interweave with rough tenderness in his paintings, the harvests desiccated by the sun, the river from which bathing children emerge, and finally, the air, the air that remembers, that thinks, that knows, that wishes . . . all of these noble forms he calls to life evoke in us something akin to a religious feeling, for they give us the sense that, as in biblical times, words will spring from the trees and the rocks, that everything is awaiting the redeemer, that the world yearns for a lord, that the Provençal soul would descend into one of us.[1]

Thus ran the poet Joachim Gasquet's words of praise for one of the most beautiful and historically significant regions in the south of France, and for the artist who lent it undying expression. The majestic calm of Cézanne's depictions of the gently rolling hills and bizarre rock formations, the broad plains and sunbaked plateaus of Provence struck Gasquet with the force of a revelation.

Provence exerted a magnetic attraction on Cézanne throughout his life. The landscape in the vicinity of his parents' house, in particular, but also the seacoast near Marseille, the villages around Aix-en-Provence, the formations of Mont Sainte-Victoire provided him again and again with key motifs on his quest for valid pictorial expression. These motifs, in turn, permit us to trace a stylistic development that ranges from the dark-hued, heavily

The Sea at L'Estaque,
1895-98

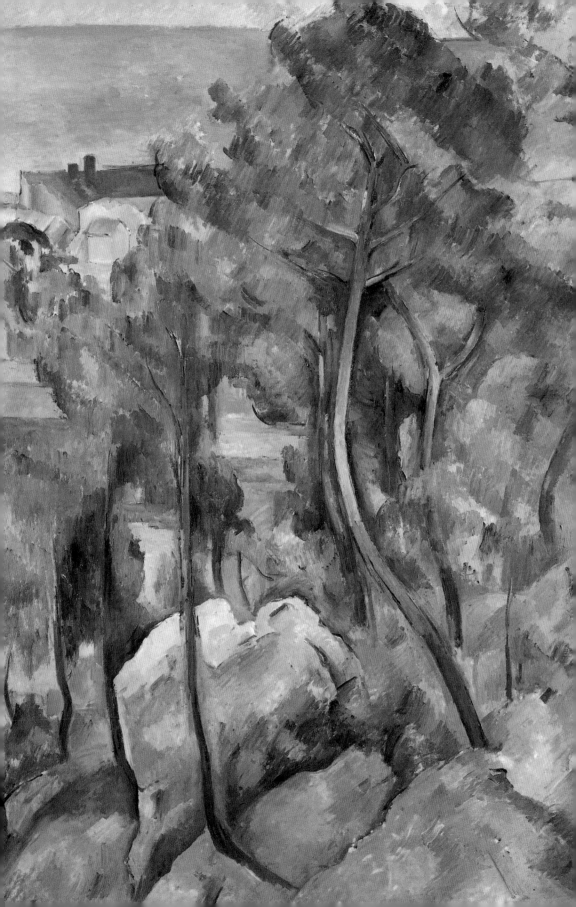

impasted landscapes of the 1860s to the translucent luminosity of the artist's mature phase at the turn of the century.

Cézanne had a happy childhood. One of his favorite pastimes was to explore the environs of his home town, Aix-en-Provence, with his friends Emile Zola and Jean-Baptiste Baille. These outings apparently remained a source of inspiration to the end of his life: "It is impossible not to be deeply moved when we think of this beautiful time gone by, of this atmosphere which we breathed without being aware of it, and which is no doubt the cause of the present spiritual state in which we find ourselves."[2] Then, as later, the bright Mediterranean light, the mountains and hills, the villages clinging to the slopes, appealed to him in his search for permanence and truth: "Always the sky, the boundless things of nature, attract me and give me the chance to look with pleasure."[3]

Mountains in Provence,
1886-90

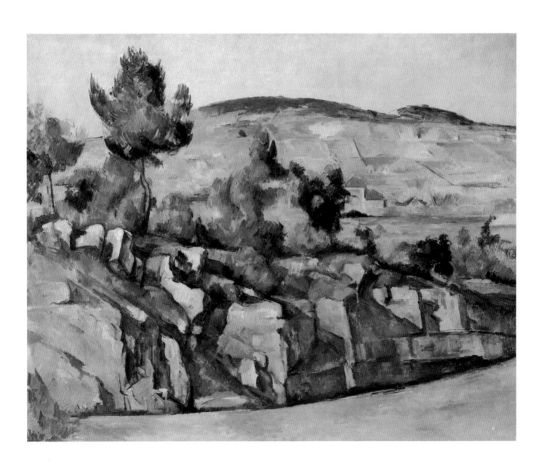

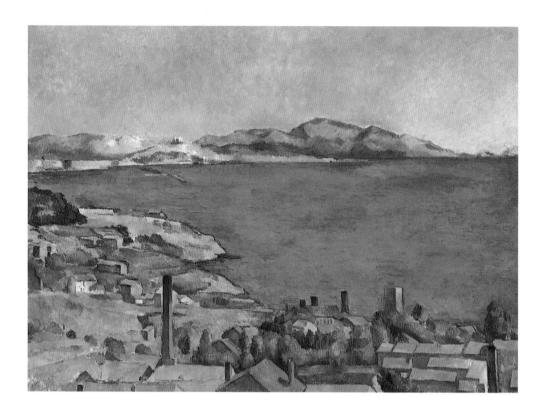

*The Gulf of Marseille
Seen from L'Estaque,*
ca. 1885

Overleaf:
Provençal Landscape,
ca. 1878

The Provençal countryside not only possesses a special quality of permanence, changing but little in the course of the seasons; it is also one of the most ancient seats of European civilization. In the first millennium B.C., the region witnessed the defeat by the Celts of the first tribe there to be known by name, the Ligurians, who settled in Provence in the late Bronze Age. When the seafaring Greeks who inhabited the coast were besieged by the Celts, they called in Roman aid. The decisive battle took place in 123-122 B.C. It resulted in a Roman victory, in the wake of which the entire region came under the sway of Rome. This represented probably the most lasting influence to which Provence has been subjected, one still testified to by a great number of Roman ruins.

Following a period of flourishing cultural and economic activity under the protection of the Pax Romana, in the fifth and sixth centuries Provence fell under the rule of successive waves of invaders from the north and east. Subsequently, it became a part

9

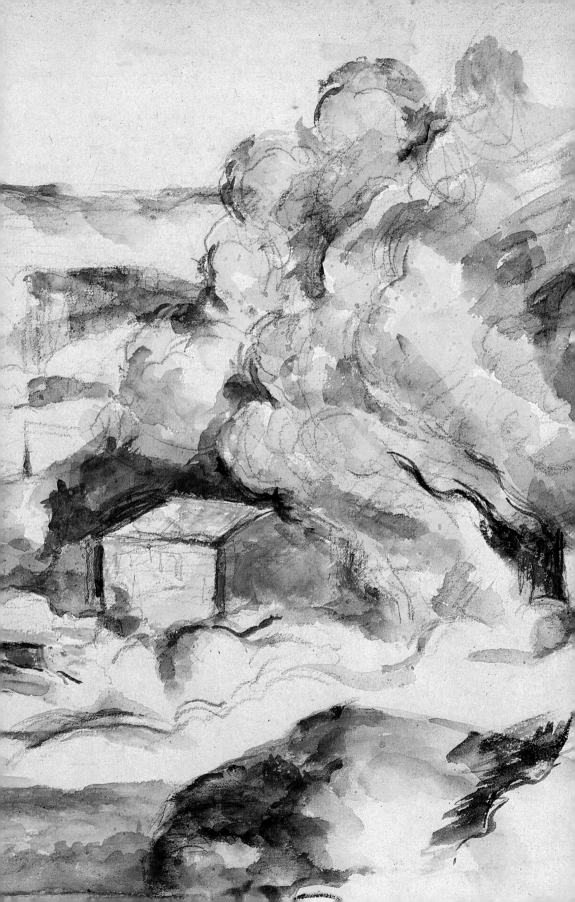

of the Holy Roman Empire, which in the thirteenth century ceded the region to the royal dynasty of Anjou. The viceroys gradually wrested a considerable degree of independence from the empire; under René d'Anjou, the Good (1434-80), the region at last began to prosper again. Yet in 1481, when his successor, Charles III of Maine, bequeathed it to the French kingdom, Provence reverted to provincial status. The inhabitants reacted by holding fast to their local customs and language, covertly resisting all influence from the court in Paris. There ensued the bloodiest period in Provençal history—the Wars of Religion in the sixteenth and seventeenth centuries. It was not until 1787 that peace finally returned, with the signing of the Protestant Edict.

This was the region to which Cézanne, feeling ever more uncomfortable in society as he grew older, returned again and again. Although he felt his career required him to spend time in Paris occasionally, it was only in Provence that he could be at one with himself and his beloved countryside. It was, perhaps, this strong sense of home that led him to paint variation after variation on a small number of Provençal motifs, which evoke the cultural identity of the region, its living, lasting presence over the centuries: "To conclude, I must tell you," the artist wrote to a friend, the collector Victor Chocquet, "that I am still occupied with painting and that there are treasures to be taken away from this country, which has not yet found an interpreter equal to the abundance of riches which it displays."[4]

The Joys of Boyhood

Paul Cézanne was born in Aix-en-Provence, capital of the former kingdom of Provence, on January 19, 1839. His father, Louis-August Cézanne, was a hatmaker, whose family name derived from a village near Briançon. Paul's mother, Anne-Elisabeth-Honorine Aubert, a clerk in the hatter's shop, was not married to the father of her child. This, apparently, was no great source of concern to the couple, for two years later they had a daughter, Marie. It was not until 1844, when Paul was enrolled in school, that his parents married. His second sister, Rose, was born legitimately in 1854.

Louis-Auguste rapidly advanced to become a partner in the successful hatmaking business. When the Bargès Bank in Aix collapsed in 1848, he and his colleague Cabassol, a former cashier, established their own bank, the Banque Cézanne & Ca-

Paul Cézanne,
ca. 1861

bassol. Now that the Cézanne family belonged to the town's well-to-do bourgeoisie, they transferred their son Paul, in 1852, from the Jesuit Ecole de Saint-Joseph to the more prestigious Collège Bourbon, where he soon met Emile Zola.

Emile's father was an engineer responsible for planning a dam and reservoir to supply water to Aix, but he died while the project was still under construction. He was of Italian origin, which, in the xenophobic atmosphere of the town, made Emile something of an outsider. Paul, angered by the jeers and taunts of their fellow pupils, stood up for the weaker boy, planting the seed of what would grow into an extremely close friendship. The fledgeling artist and writer were soon joined by Jean-Baptiste Baille, the son of a local innkeeper, who shared many of their enthusiasms. The trio, dreaming of a common career in the arts, went on long excursions into the countryside around Aix—over to Mont Sainte-Victoire or to the banks of the Torse and Arc rivers. After going for a swim they would sit for hours, talking and reciting their favorite poems, or their own new compositions. Several letters from the period, illustrated with drawings, reveal Paul's early interest in the motif of bathers (illus. p. 16). It must have been the happiest time of his life:

Jean-Baptiste Baille
at the age of 20

Our soul still pure,
Walking with a timid step,
Has not yet struck
The edge of the precipice
Where so often one stumbles
In this corrupt age.
I have not yet raised
To my innocent lips
The bowl of voluptuousness
From which souls in love
Drink to satiety. [5]

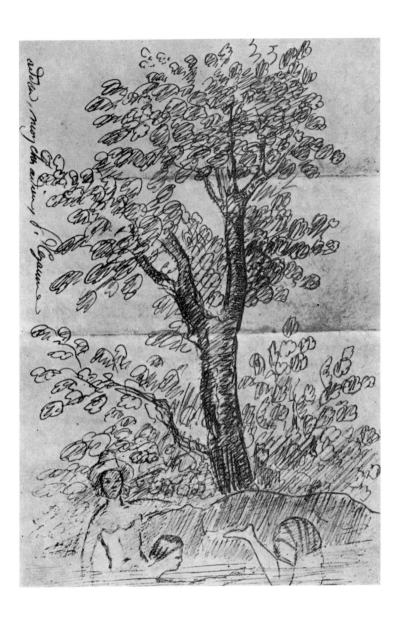

In his novel *L'Œuvre* (*The Masterpiece*), Zola describes these halcyon days of youth:

Born within a few months of each other, but vastly different in both temperament and social background, they had soon become bosom friends, drawn together by subconscious affinities, the vague feeling of ambitions in common, the awakening of a higher intelligence among the vulgar herd of dunces and dunderheads they had to contend with in class.…While they were still in elementary school the three inseparables had developed a passion for long walks. Not even a half-holiday went by without their covering a good few miles and, as they grew older and more venturesome, their rambles covered all the surrounding district and even on occasion took them away from home for days at a time.… In their unthinking, boyish worship of trees and hills and streams, and in the boundless joy of being alone and free, they found an escape from the matter-of-fact world, and instinctively let themselves be drawn to the bosom of Nature.… They

Drawings in three
of Cézanne's letters
to Zola

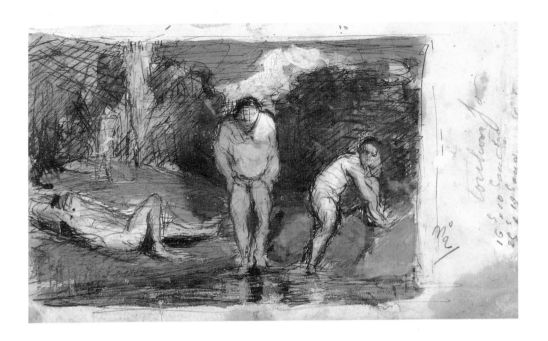

could swim when they were scarcely twelve, and they loved to splash about in the deeper parts of the stream; they would spend whole days, stark naked, lying on the burning sand, then diving back into the water, endlessly grubbing for water-plants or watching for eels.[6]

Their enjoyments came to an abrupt end in 1858, when Zola moved to Paris. In a letter of 1860, Zola wrote to Baille: "When the three of us met at the beginning of our lives and—urged by an unknown force—seized each other by the hand and swore never to separate, not one of us inquired about the wealth and possessions of his new friends. What we were looking for was the value of heart and mind and, most of all, that future which our youth dangled so attractively in front of our eyes."[7]

Search for Recognition:
Back and Forth between Paris and Aix

As long as Cézanne's excursions with his friends continued, he was able at least partially to escape his father's strict control. Louis-Auguste can be described as a typical parvenu. After his rapid rise from hatmaker to banker, he felt his newfound status required a visible symbol. So in 1859 he bought a country house outside Aix, a former aristocratic residence called the Jas de Bouffan (roughly, House of the Wind). In the reign of Louis XIV it had been occupied by Marquis de Villar, the governor of Provence. As it had stood empty since the eighteenth century, the house must have been in very poor condition when Cézanne's father bought it. He decided, however, that a complete renovation would be too expensive, and the family had to be satisfied with occupying only some of the rooms.

Paul felt far more at home in the Jas de Bouffan than in town, where people whispered among themselves about the "illegitimate son of a social climber." He used to disappear for days in the studio that his father had permitted him to set up. Although highly critical of Paul's desire to become an artist, Louis-Auguste agreed to let him decorate the salon with allegorical depictions of the seasons. Strangely enough, Cézanne signed these paintings, done around 1860, "Ingres, 1811." Six years later he was to add *Louis-Auguste Cézanne Reading "L'Evénément"* (illus. p. 21). From that point on, reflecting his paternal authority and dominance, Louis-Auguste sat at the center of the mural, attended by the Four Seasons.

Yet commissions of this type did not satisfy the young artist: in his heart of hearts he wished to go to Paris, where Zola awaited him. Plead as Paul might, his father refused to countenance the idea. This obstinacy later prompted Zola to base one of his characters on Louis-Auguste: the unsympathetic François Mouret in *The Conquest of Plassans*. "Take the type of Cézanne," Zola noted to himself. "Cynical joker, republican, bourgeois, cold, timid, miserly. Inside view: he refuses luxury to his wife. And he is also a braggart who stands on his fortune and makes fun of everybody else."[8]

The artist's father,
Louis-Auguste
Cézanne

Facing page:
*Louis-Auguste Cézanne
Reading "L'Evéné-
ment"*, 1866

Zola's picture of the town of Plassans, based on Aix-en-Pro-
vence, is equally forbidding:

About twenty years ago, owing, no doubt, to the lack of intercommu-
nication, there was no town that had preserved more completely the
devout and aristocratic character which distinguishes the old Pro-
vençale cities.... The distinction of class was preserved for a long time
by the division of its various districts.... As if to keep more isolated
and shut up within itself, the town is surrounded by a belt of old ram-
parts, which only serve to increase the gloom of the place, and to ren-
der it more confined.... They are pierced with several openings....
These gates were double-locked at eleven o'clock in summer, and ten
o'clock in winter. The town, having thus shot the bolts like a timid
girl, went quietly to sleep. A guardian, who lived in a little cell placed
in one of the interior angles of each gateway, was authorized to open
for any belated persons. But it was necessary to stand parleying a long

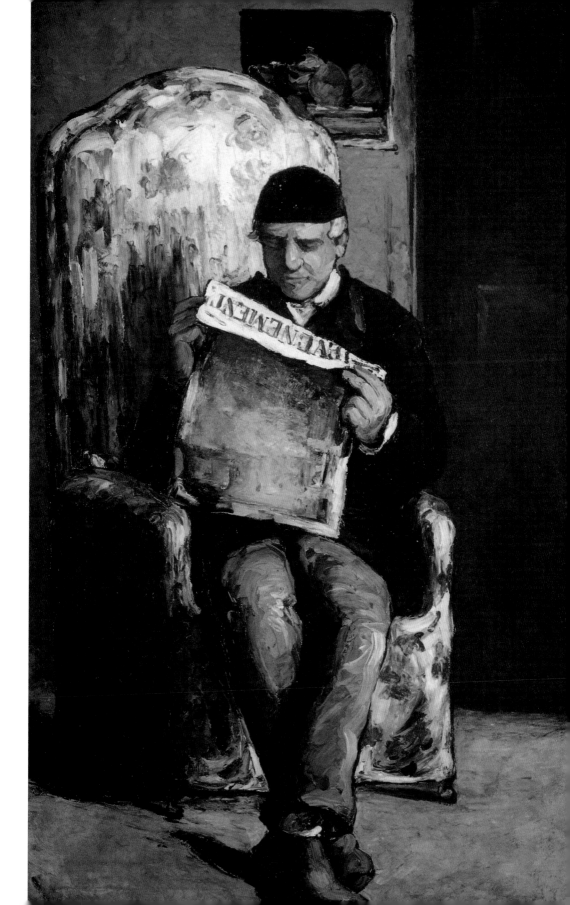

time. The guardian would not let the people in until he had scrutin- ized their faces carefully through a peep-hole by the light of his lan- tern; if their looks displeased him they had to sleep outside. This custom of locking the gates every evening is highly characteristic of the spirit of the town, a mixture of cowardice, egotism, routine, ex- clusiveness, and religious longing for a cloistered life. Plassans, when it had well shut itself up, would say to itself, "I am at home," with the satisfaction of a devout citizen, who, assured of the safety of his cash-box, and certain not to be roused by any noise, says his prayers and retires gladly to bed. No other town has, I believe, per- sisted so long in incarcerating itself like a nun.[9]

Zola's criticism extended to the political and social structures of the town as well:

Even at the present day the popular voice is stifled there; the middle classes bring their prudence to bear, the nobility their mute despair, and the clergy their shrewd cunning. Kings may usurp thrones, or re- publics be established, and this barely causes any commotion in the town. Plassans is asleep while Paris is fighting.... The priests, who are very numerous, prescribe the political colors of the place; they con-

Place des Prêcheurs,
Aix-en-Provence,
ca. 1900

The bandstand in Place Jeanne d'Arc, Aix-en-Provence, ca. 1900

stitute, as it were, the subterranean mines and the blows in the dark, adopting a prudent, timorous system, which hardly effects a single step in advance or retreat in the space of ten years. These secret intrigues of men who desire above all things to avoid a disturbance require a special shrewdness, an aptitude for small matters, and the endurance of persons callous to all passions. It is thus that the provincial dilatoriness, which is so freely ridiculed at Paris, is full of treachery, of secret butchery, of hidden victories and defeats. These worthy men, particularly when their interests are at stake, kill at home with a snap of the finger, as we kill with a cannon in the public thoroughfare.[10]

In an environment as narrow-minded as this, Cézanne could hardly expect to find much support for his artistic ambitions.

The artist's early letters attest not only to a desire to be reunited with his friend Zola, but also to a vacillation between poetry and painting—many letters contain verses—and to his inability to pursue either activity intently. Instead, Cézanne bowed to his

father's wish and, after he had passed the final school examinations on his second try, enrolled in the University of Aix to study law. In his spare time he took drawing courses under Joseph Gibert at the Musée Granet, where he met a few of his old schoolfellows. As weeks and months passed in the daily grind of law studies, with the only prospect before him that of spending the rest of his life in his father's bank, Cézanne began to grow uneasy. He sent off a cry of help, in rhyme, to Zola:

Alas, I have chosen the tortuous path of Law.
—I have chosen, that's not the word, I was forced to choose!
Law, horrible Law of twisted circumlocutions,
Will render my life miserable for three years.
Muses of Helicon, of Pindus, of Parnassus,
Come, I beg you, to soften my disgrace.
Have pity on me, on an unhappy mortal,
Torn against his will away from your altar.[11]

The Overture to "Tannhäuser", 1869-70

Cézanne's father long remained deaf to his son's continual pleading. In Louis-Auguste's view, jurisprudence would give Paul a solid footing in life and, as a bank clerk, he would have an ade-

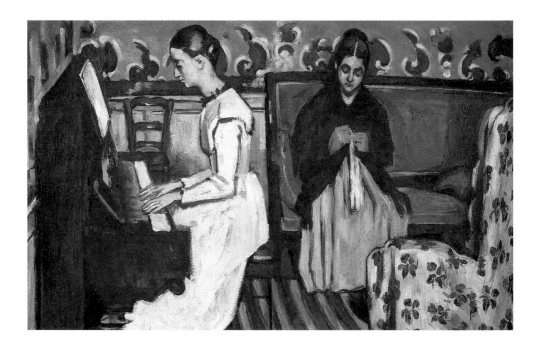

Edouard Manet,
Portrait of Emile Zola,
1868

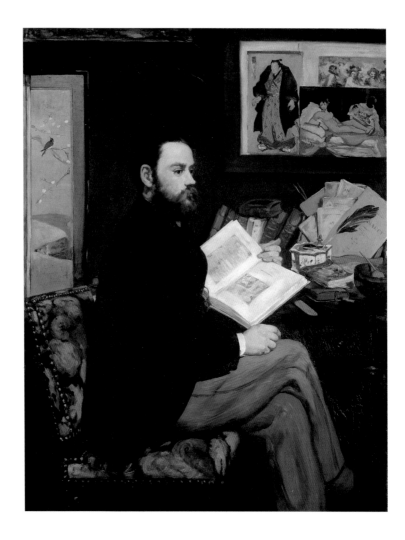

quate income. The life of an artist, in contrast, appeared not only rather disreputable to Louis-Auguste, but also highly insecure. Possibly, he was counting on his son's shyness and love of his native region when, in 1861, he finally let Paul travel to the capital. At any rate, hardly had the 22-year-old arrived in Paris when he began talking about a return to Aix. As he wrote that year to his boyhood friend Joseph Huot: "I thought that when I left Aix I should leave behind the boredom that pursues me. I have only changed place and the boredom has followed me. I have left my parents, my friends, some of my habits, that's all.... Do not think that I am becoming Parisian."[12] After struggling for three years to be able to

make the trip, Cézanne returned to Aix after only five months, having accomplished almost nothing.

Living in the provinces, however, proved unexpectedly difficult. Cézanne bowed to his father's wish and went back to work in the bank. Yet, finding the situation increasingly insufferable, he began to contemplate another escape to Paris as the way out. This time it was not only Zola's entreaties, but also his own conviction that led him to pursue in earnest a career in art. He began to study painting with great zeal. Several self-portraits and portraits resulted, among them one of Zola (illus. p. 15).

Cézanne arrived in Paris for the second time in November 1862. Although his father would like to have seen him at the Ecole des Beaux-Arts, he was not accepted there. Instead, he enrolled at

Seated Male Model,
1865-67

Male Nude, 1863-66

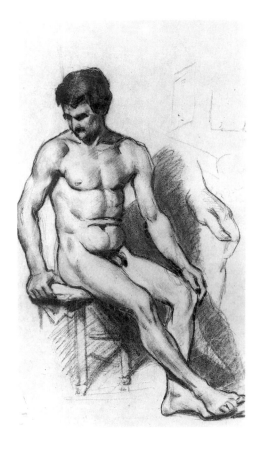

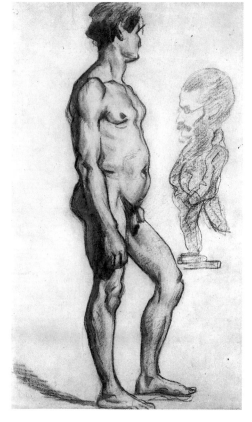

Reclining Female Nude,
1882

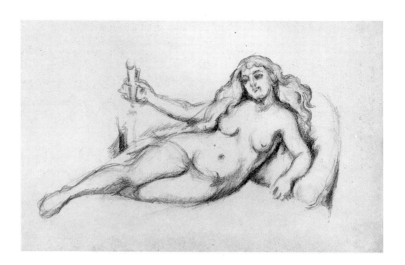

the Académie Suisse, which he was to attend regularly until 1864. Cézanne remained very much an outsider among his fellow students and felt himself a stranger in Paris despite the presence of Zola and the fact that he made the acquaintance of the Impressionist painters Auguste Renoir, Claude Monet, Alfred Sisley, and Camille Pissarro. In 1864 he began to divide his time between Paris and Aix.

Excursions to L'Estaque and Auvers:
The New Landscape

Cézanne initially showed little interest in landscape motifs. It was only when he began to return regularly to Provence from Paris that he devoted more and more of his time to them. Together with his friend Antoine Fortuné Marion, a natural scientist who explained the local geological formations to him, Cézanne roamed the environs of Aix, painting from nature—"sur le motif," as he was later to term it. Writing to Zola, he emphasized the advantages of working outdoors: "But, you know, all pictures painted inside, in the studio, will never be as good as those done outside. When out-of-door scenes are represented, the contrasts between the figures and the ground are astounding and the landscape is magnificent. I see some superb things and I shall have to make up my mind only to do things out-of-doors."[13]

Cézanne's early landscapes exhibit the same vehemence and expressiveness of handling as his contemporary figure paintings. The primarily dark colors are applied to the canvas with a palette knife or a broad brush. Frequently, the landscape is strongly contrasted to a bright band of sky, as in *Winding Road in Provence* (illus. opposite). The wide, light-hued road, flanked by a few bushes and trees, leads steeply inward and upward into the middle ground of the picture. Behind it rises a mountain mass. A tall pine at the edge of the road forms the sole link between the three horizontal bands of the composition. This solitary tree might be compared to Cézanne himself, who, like it, was rooted in the Provençal soil and who resisted the antagonism of his environment as the slender pine resists the harsh mistral winds.

The calm of the scene has something oppressive about it and the impulsive brushwork lends the landscape great drama. In keeping with Zola's definition of the work of art as "a corner of creation seen through a temperament,"[14] Cézanne's choice of motifs reflected his own underlying mental conflicts and desires. Like the road in the picture, his own life's road seemed to lead in no particular direction. The constricting vegetation may reflect the pressure and harrassment he experienced at the hands of his

Winding Road in Provence, 1867-68

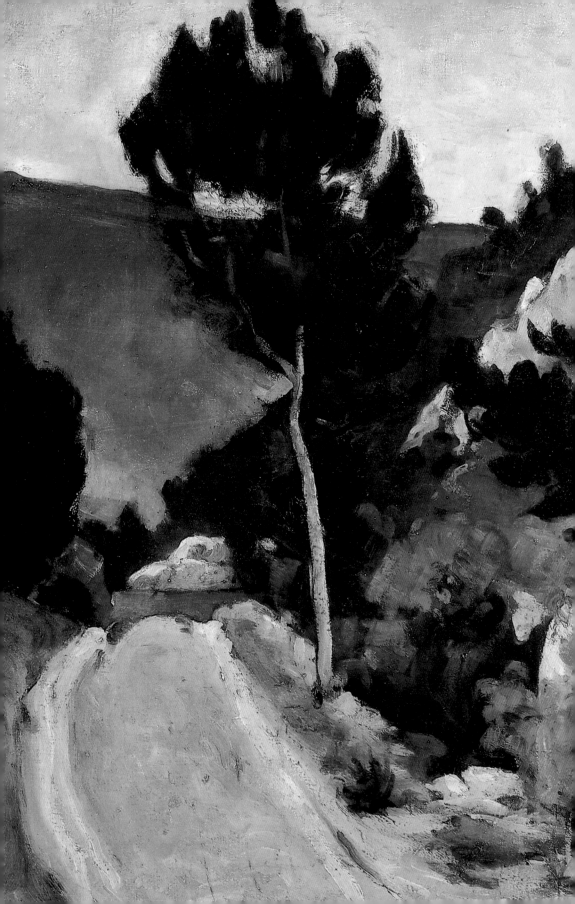

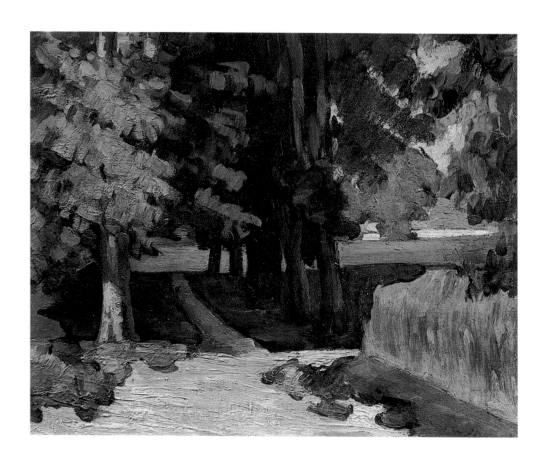

The Chestnut Trees and the Pool at the Jas de Bouffan, ca. 1869

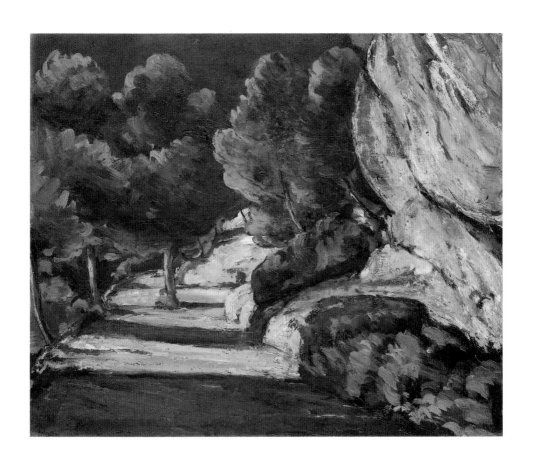

Rocky Landscape near L'Estaque, 1870-71

family in Aix. And, just as the pine rises from the Provençal earth to reach above the stifling narrowness below, so the young artist yearned to reach the narrow band of sky that signified freedom.

When the Franco-Prussian War broke out on July 18, 1870, Cézanne left Paris for the south in the hope of avoiding conscription. After working in Aix for a time, he went on to L'Estaque, a town about twenty miles away, on the coast near Marseille. Here, Cézanne set up house with Hortense Fiquet, with whom he had become acquainted the previous year. Hortense was only nineteen years old at the time. She came from Saligny in the Jura Mountains and worked as a bookbinder and artists' model in Paris, living with her mother in more than humble conditions. When Cézanne met her, he immediately anticipated his father's objections to a relationship with the young woman; but to the artist, it meant a release from repressed sexual desires and from a frustrated longing for love and recognition. How deeply these things preoccupied him may be seen from such early canvases as *An Afternoon in Naples*, *A Modern Olympia*, and *The Eternal Feminine* (illus. pp. 33, 35, 37).

Not even when their son, Paul, was born in 1872 did Cézanne find the courage to tell his father of his liaison with Hortense. Still dependent on him for financial support, the artist found it not only diffucult to ask his father for money, but also extremely humiliating. The result was a feeling of hate that became apparent in his letters, as in this one to Pissarro: "Here I am with my family, with the most disgusting people in the world, those who compose my family, stinking more than any. Let's say no more about it."[15]

In other letters, especially to his parents, Cézanne adopted a more conciliatory tone. In 1874 he wrote:

You ask me in your last letter why I am not yet returning to Aix. I have already told you in that regard that it is more agreeable for me than you can possibly think to be with you, but that, once at Aix, I am no longer free and when I want to return to Paris this always means a struggle for me; and although your opposition to my return is not absolute, I am very much troubled by the resistance I can feel on your part. I greatly desire that my liberty of action should not be impeded and I shall then have all the more pleasure in hastening my return.

I ask Papa to give me 200 francs a month; that will permit me to make a long stay in Aix, and I shall be very happy to work in the South,

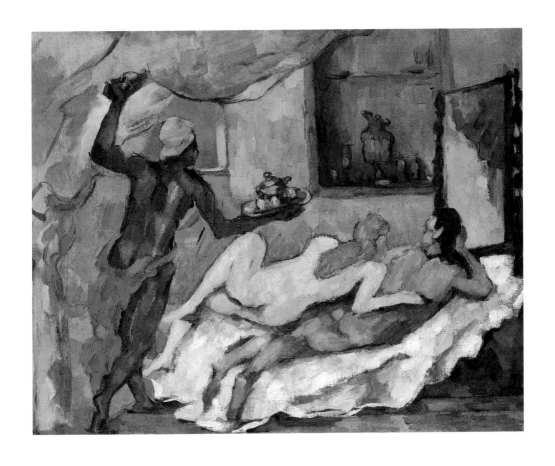

An Afternoon in Naples (Rum Punch), 1876-77

where the views offer so many opportunities for my painting. Believe me, I do really beg Papa to grant me this request and then I shall, I think, be able to continue the studies I wish to make. P. S. Here are the last two receipts.[16]

Cézanne obviously still feared that his father might change his mind and insist upon his returning to the bank. Although the letter was addressed to both parents, it was evidently his father whom Cézanne hoped to convince, for his mother was basically in favor of his pursuing a career as an artist. Also, she knew of Hortense, she knew that she had a grandchild, and she knew that the 200 francs were intended largely for the support of her son's family.

When the true situation finally began to dawn on Louis-Auguste, Paul feared he might be cut off entirely. To Zola he wrote: "I find myself very near to being forced to obtain for myself the means to live, always provided that I am capable of doing so. The situation between my father and me is becoming very strained and I am threatened with the loss of my whole allowance. A letter that Monsieur Chocquet wrote to me and in which he spoke of Madame Cézanne and of little Paul, has definitely revealed my position to my father, who, by the way, was already on the watch, full of suspicion and who had nothing more urgent to do than to unseal and be the first to read the letter, although it was addressed to: Mons. Paul Cézanne—artist, painter."[17]

Zola consoled his friend and even offered him financial aid. Encouraged, Cézanne decided to attempt another interview with his father. To Zola he replied:

> I think, as you do, that I should not too hastily renounce the paternal allowance. But judging by the traps that are laid for me and which so far I have managed to avoid, I foresee that the great discussion will be the one concerning money and about the uses I must put it to. It is more than probable that I shall not receive more than 100 francs from my father [instead of the previous 150 a month], even though he promised me 200 when I was in Paris. I shall therefore have to have recourse to your kindness, all the more so because my little boy has been ill with an attack of paratyphoid fever for the last fortnight. I am taking all precautions to prevent my father from gaining absolute proof.... If, therefore, my father does not give me enough, I shall appeal to you in the first week of next month, and I shall give you Hortense's address, to whom you will be kind enough to send it.[18]

A Modern Olympia, 1872-73. Detail

Cézanne was long to remain dependent on Zola's monthly payments, after his father cut off his allowance entirely in an attempt to force a break with Hortense. It took years of persuasion on the part of the artist's mother and of his sister Marie to convince Louis-Auguste to tolerate the relationship. To make matters worse, in 1885 the entire family was up in arms about a passionate love affair that Paul apparently was having with an Aix woman. So, as if preferring the lesser evil, his mother and sister now began to make every effort to get Paul and Hortense married. The couple's feelings for one another, however, had cooled considerably and Cézanne felt more affection for his son than for Hortense. When they were finally married on April 28, 1886, evidently neither he nor his wife considered the act to be much more than a formality, for they continued to spend very little time with each other.

Cézanne's stay, in 1870-71, in the remote fishing village of L'Estaque not only kept him out of the clutches of his father and the army, but also screened him from current political events. Only scraps of news about the defeat of Napoleon III, the Prussian invasion, the French capitulation, and the political experiment of

Nudes in a Landscape,
1864-67

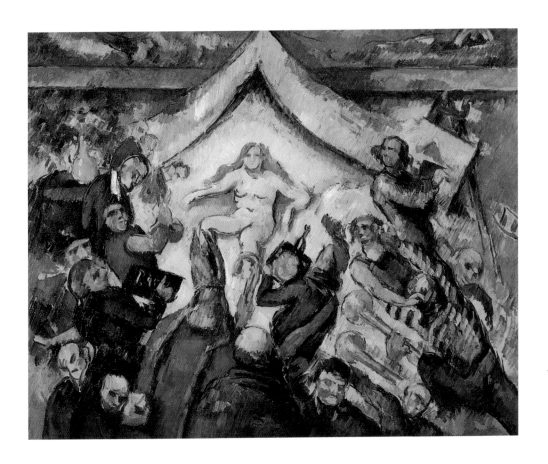

The Eternal Feminine,
1875-77

the Commune reached his ears. In March 1871 he left L'Estaque for Aix, where he remained until the autumn, before returning to Paris. According to art dealer Ambroise Vollard, Cézanne later recalled: "During the war I did a great deal of work from nature at L'Estaque. Now that I come to think of it, I have nothing extraordinary to tell you about the years 1870-71. I divided my time between the countryside and my studio.... There was a landscape then that I just couldn't get right, so I spent a little more time studying from nature."[19] Such statements reflect Cézanne's unworldliness and his self-chosen isolation from society, character traits that were to grow ever stronger with age.

Yet the artist's state of mind at the time was anything but tranquil. This may be deduced from a canvas such as *Melting Snow at L'Estaque* (illus. p. 40). Although it treats a familiar Impressionist

subject, this winter scene entirely lacks the charming, elegant play of light characteristic of that style. A glowering sky hangs threateningly over slopes, covered with dingy snow, whose descending diagonals offer no hold for the eye. The windswept pines seem on the verge of toppling over. The descending horizon line further induces in the viewer the impression that he or she is being drawn into a vortex. The two diagonals of the composition converge on the red roofs, which form the sole accent of color in this gloomy landscape.

That Cézanne was developing an entirely new approach to nature and its representation becomes apparent in *Railroad Cutting* of 1870 (illus. pp. 42-43).[20] Although the reddish-brown earth colors still show strong contrasts of light and dark, the landscape as a whole has become lighter in tone. The paint is still applied thickly, but perspective has been largely eliminated, depth being expressed instead by means of flat, overlapping zones. The railroad cutting, in the middle ground, is depicted with such detached precision as to give this incursion into the natural environment positively violent overtones—a gaping wound inflicted on nature by progress, in the shape of the railroad. Cézanne did indeed often express publicly his aversion to the changes brought about by modern technology, be it road construction in Aix or industrial development in L'Estaque.

Railroad Cutting is suffused with a menacing calm. The landscape motif, lent substantiality by the heavy impasto, is framed on the left by a house and on the right by Mont Sainte-Victoire. Visible to the right, behind the hill, is the tower of Aix cathedral. This particular arrangement of house, railroad cutting, Mont Sainte-Victoire, and cathedral tower does not correspond to reality. Cézanne must have had a reason for combining them as he did. The motif of the cutting is juxtaposed to the pristine mountain, as if to contrast the transient works of humankind to the permanence of nature. A similar contrast is found in the house and cathedral, the one a mundane, utilitarian structure, the other a sacred building, dedicated to lasting ideals, that had stood there for centuries. The composition, then, is characterized by symbolic opposition between the short-lived and the eternal.

Madame Cézanne in a Red Armchair, 1877-78

Cézanne felt threatened by the inexorable process of modernization and the changes in daily life that it brought, and his return

38

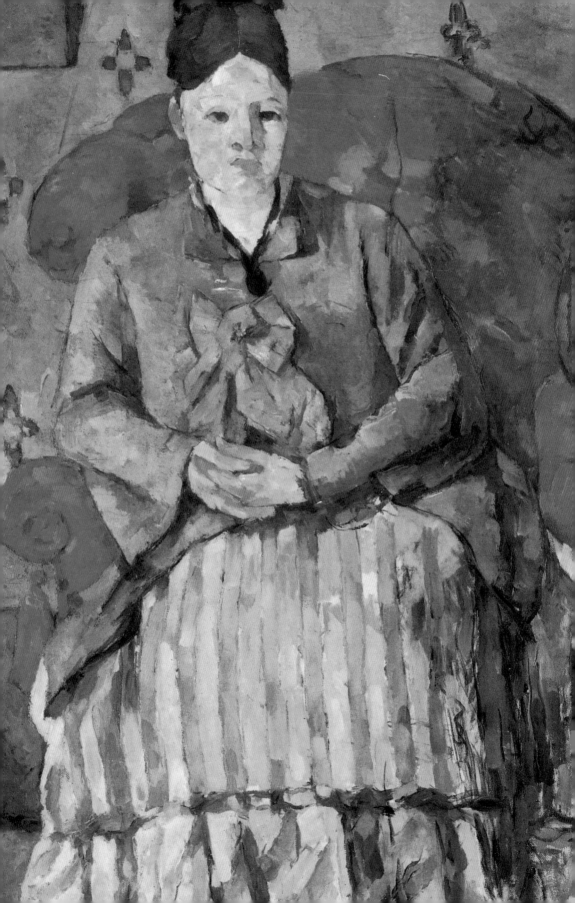

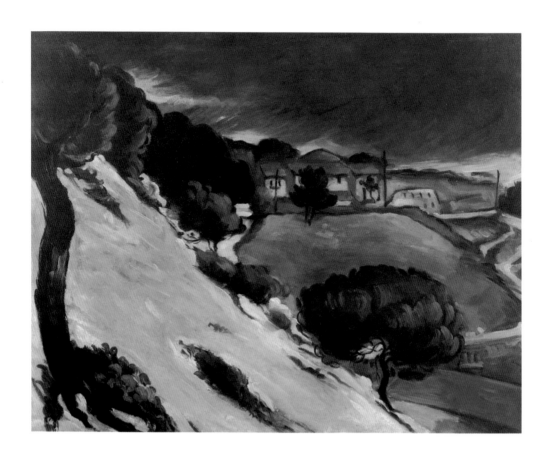

Melting Snow at L'Estaque, ca. 1870

to nature was a way of finding peace of mind. *Railroad Cutting* is, however, no idyllic invocation of natural harmony; it is a merciless depiction of nature alienated. In his early work the artist had shocked the public by combining unusual subjects with deliberately crude execution; now he began to channel his emotions, and to represent his discontent with society, in a more objective, but no less compelling way.

When Cézanne returned to Paris in 1871 he was still searching for a style that would meet the high demands he placed on himself. Yet first he had to pass through the school of Impressionism, in which his mentor was Pissarro. In 1872 and 1874 the two friends painted together in Pontoise and Auvers.

Pissarro's influence is evident in the early landscapes done in the vicinity of the Jas de Bouffan. Cézanne's palette has grown lighter and his technique combines the rendering of shimmering

effects of light with stringent composition. He has transposed the carefree Impressionism of the Ile-de-France to the harsh landscape of Provence, with its far more intense colors and light.

Trees in the Park at the Jas de Bouffan (illus. p. 47) is a composition of almost banal simplicity: trees and shrubs surrounding a small wooden shed, a tumbledown picket fence running across the picture, and hills rising in the background. Taking Pissarro's advice, Cézanne no longer applied paint to the canvas with a palette knife or broad bristle brush, but used short, parallel strokes to build up the surface. In contrast to the airy lightness of Pissarro's style, however, Cézanne's brushstrokes continued to form a coherent structure and never deprived objects of solidity. In the end, the Impressionist technique contributed little to the valid expression of landscape, the "réalisation" that Cézanne sought. This may be seen from the crystalline rigor with which foreground, middle ground, and background in *Trees in the Park at the Jas de Bouffan* are structured.[21] And, characteristically for Cézanne, the composition is lent a solid framework by carefully placed horizontals and verticals: fence and horizon line, offset by tall trees.

In sum, Impressionism remained no more than a transitional phase in Cézanne's development. Despite the interest shown in his work by such an influential personality as art dealer Paul Durand-Ruel, to whom Pissarro had introduced him, Cézanne's participation in the Impressionists' exhibitions did not bring him the recognition he expected. When, in 1874, three of his pictures were included in the independent group show at the studio of the photographer Nadar (*The Maison du Pendu, View of Auvers,* and *A Modern Olympia*; illus. pp. 44, 46, 35), they elicited little more than derision. His contributions to the two following group exhibitions fared no better and, although the Salon remained just as closed to the Impressionists as to him, Cézanne began to withdraw from their circle. He realized with ever greater certainty that it was not a spontaneous depiction of fleeting sense-impressions and effects of light that interested him, but a search for some way to represent, in form and color, the emotions aroused in him by the landscape. In other words, Cézanne's undertaking was not merely visual, but visionary, in character.

Disappointed by reactions to his work in Paris, Cézanne withdrew in 1878 to Aix, whence he made frequent trips to L'Estaque

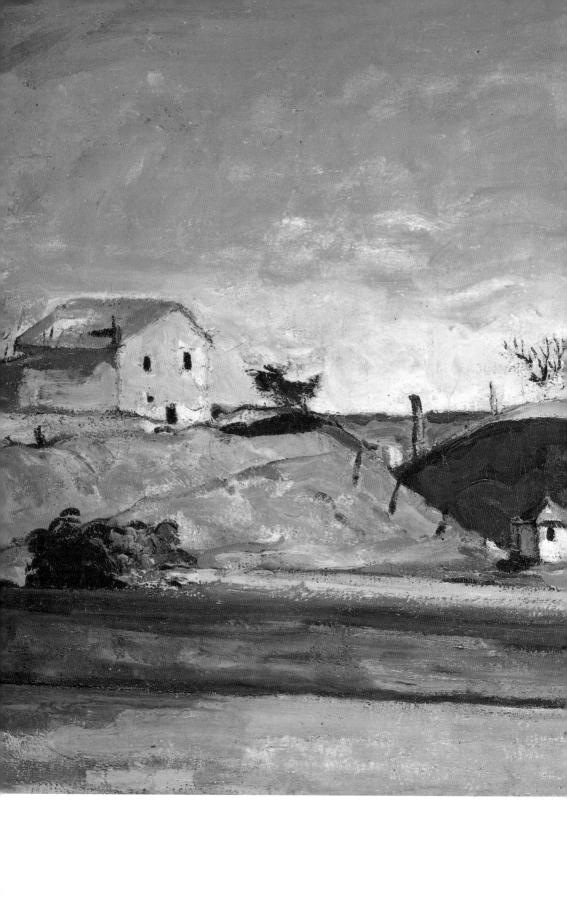

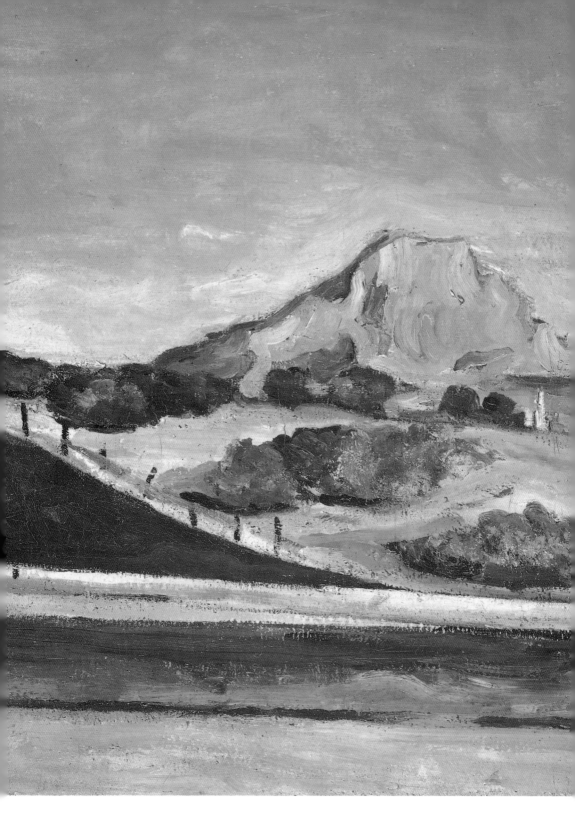

Railroad Cutting, ca. 1870

and Gardanne. He had no apartment in L'Estaque as yet, so he used to spend the night in Marseille. As in Paris, the life-style of the town and its bourgeois morality disgusted him. "You have no idea of the presumptuousness of this fierce population," Cézanne wrote to Zola. "They have but one instinct, that for money; it is said that they earn a lot, but they are very ugly.—Seen from outside, their ways of communicating are effacing the most salient features of the types. In a few centuries it will be quite senseless to be alive, everything will be so flattened out."[22]

Cézanne's style of the period can be seen as a reaction to this petty bourgeois shallowness, which he hated so much. He began to reduce his compositions more and more to essentials, rendered in increasingly solid and substantial brushstrokes. Every trace of

The Maison du Pendu,
ca. 1873

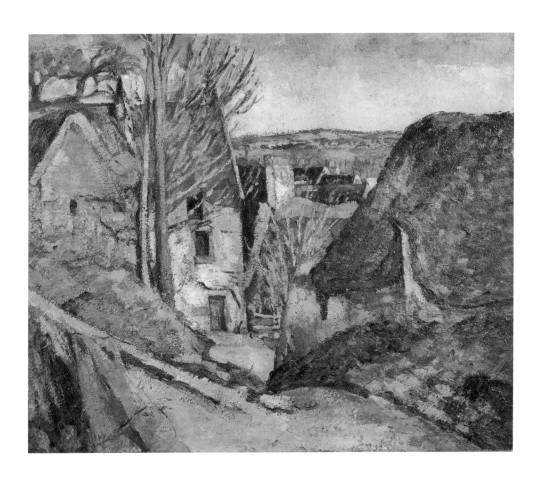

atmosphere, of the fleeting moment, was expunged. Instead of graying or lightening the colors toward the background to suggest depth—the technique known as atmospheric perspective—Cézanne employed them with the same intensity throughout the composition. This served to pull background and middle ground forward into the foreground plane, creating a visually unified surface. The landscape seemed caught in a state of suspended animation, which lent it a timeless appearance. Cézanne's translation of zones of space into zones of color permitted him to evoke depth without resorting to a form of perspective based on the laws of optics. The results suggested a relatively shallow space, in which the objects seemed interlocked in a homogeneous, dense, and intensely colored structure.

"I must tell you," Cézanne wrote to Pissarro, "that your letter surprised me at L'Estaque, on the seashore.... It's like a playing card. Red roofs over the blue sea.... But there are motifs that would need three or four months' work, which would be possible, as the vegetation doesn't change here. The olive and pine trees always keep their leaves. The sun here is so tremendous that it seems to me as if the objects were silhoutted not only in black or white, but in blue, red, brown, and violet. I may be mistaken, but this seems to me to be the opposite of modeling."[23]

The intense light of southern France, which heightens contrasts and contours, was perfectly suited to Cézanne's striving for timelessness and permanence in art. Stroke by colored stroke he worked forms up out of the white ground, letting them emerge from color rather than from line. The result was an interweaving of objects on the picture plane, in which the paint fulfilled a function entirely different from that in Impressionist landscapes. Nor did the urban scenes that figured so strongly in Impressionism hold much appeal for Cézanne, because they were too transient in character. The landscape of Provence, its aspect and vegetation relatively constant throughout the year, offered precisely the quality of permanence he sought.

In addition to pure landscape, Cézanne also devoted years to a subject that was to form a large, coherent complex within his oeuvre: that of bathers. The roots of the series, which would grow to about two hundred oils, watercolors, and drawings, can be traced back to a favorite pastime of the artist's youth—swimming

with his friends Zola and Baille in the Arc River (see illus. p. 16). In *Bathers Resting* of 1874-76 (illus. p. 18) Mont Sainte-Victoire is visible in the background. Yet a realistic portrayal of his personal experiences was not Cézanne's intention. In his "Bathers" he deliberately took up the age-old theme of the pastoral—the idyllic depiction of rural life—and, like his Old Master predecessors, he viewed the subject of the nude human figure in the landscape as symbolic of an ideal state of harmony between man and nature.

A striking feature of Cézanne's "Bathers" is the almost invariable restriction of each image to figures of one sex. This segregation of the sexes may well reflect the personal difficulties that the artist had in his relations with women, which emerge most strongly in his early works, such as *A Modern Olympia* (illus. p. 35). This probably also explains why, although Hortense Fiquet occasion-

View of Auvers, ca. 1874

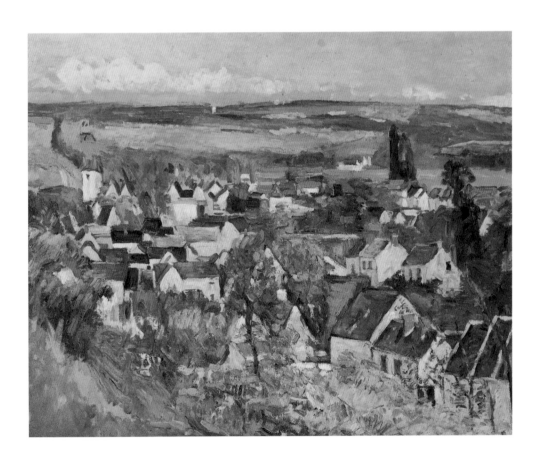

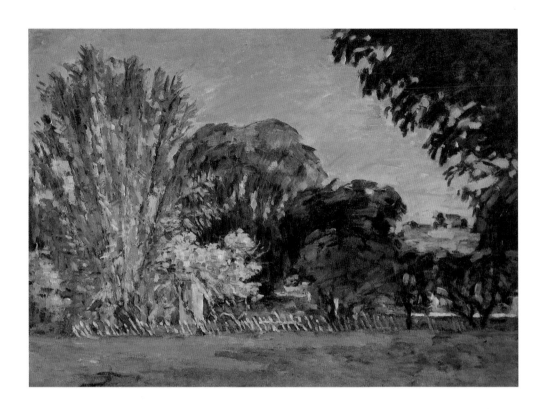

*Trees in the Park
at the Jas de Bouffan,
1875-76*

ally posed for him, Cézanne largely avoided working from the nude model when developing the "Bathers": most of the figures derive either from earlier drawings, done in life classes at the Académie Suisse or after works in the Louvre (see ills. pp. 26-27), or from photographs.[24]

The groups of figures, still comparatively small and compact in the works of the 1870s and 1880s, expanded greatly in those of the 1890s. Yet instead of being harmoniously embedded in the landscape as before, the figures now began to show an increasing tendency to strike distinctive poses. Whether crouching, reclining, or standing, they seemed not so much caught in motion as petrified, stiff as jointed dolls. The effect was increased by the strong outlines with which Cézanne initially contoured the bathers' bodies.

In the course of the 1890s these contours became sketchier, interrupted to permit internal forms to expand into the surround-

*The Sea
at L'Estaque,
1878-79*

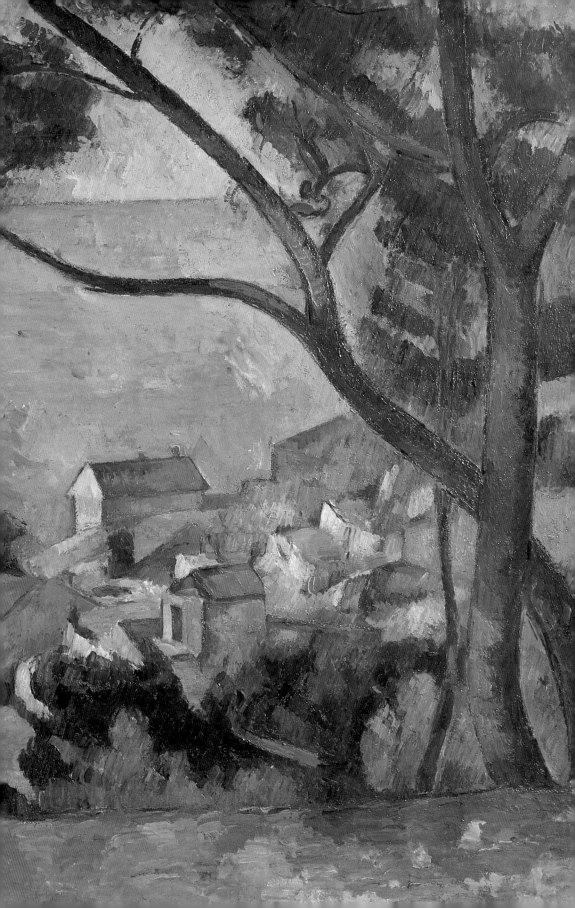

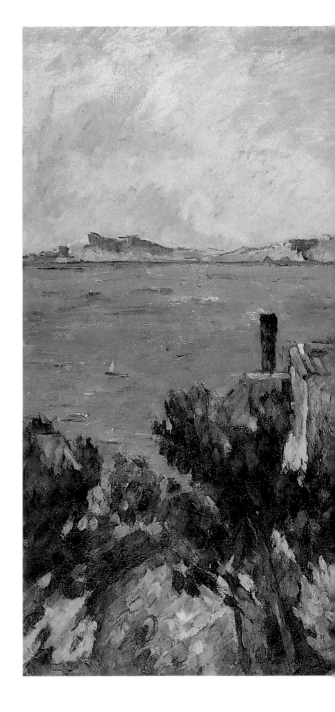

The Sea at L'Estaque, 1876

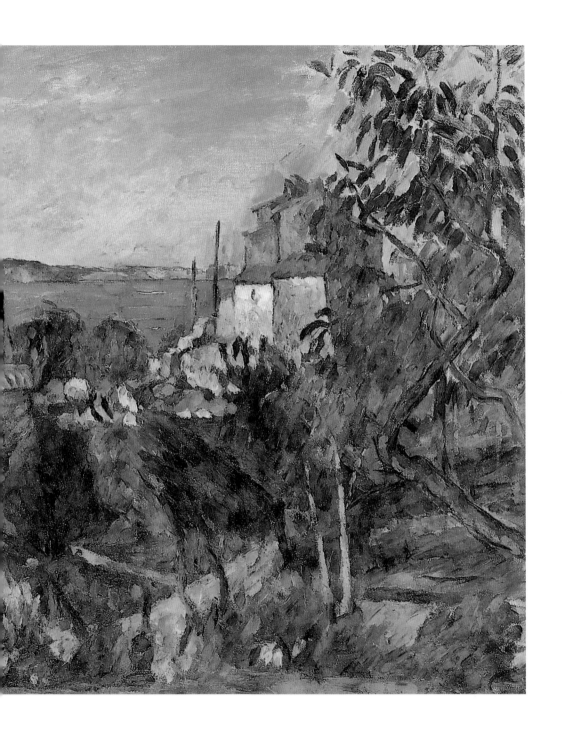

ing space. In addition, the sex of the figures grew increasingly indistinct, as they gradually developed into anonymous, androgynous beings. Landscape and figures now appeared to merge into one. As in Cézanne's pure landscapes, the separate zones of the "Bathers" were interwoven with each other by means of color, certain hues of the landscape being repeated in the figures, and vice versa.

Cézanne favored a special type of triangular composition, which is apparent in *The Large Bathers* (illus. p. 53), where nude figures are depicted against a background of trees and shrubs. The forms of the two trees at the left edge and the striding figure at the far left are echoed in the right-hand tree and in the figure bending to the right in front of it. The leftward movement of the two middle-ground figures on the right finds a counterpart in the figure in a corresponding position in the left half of the picture.

Bathers, 1900-04

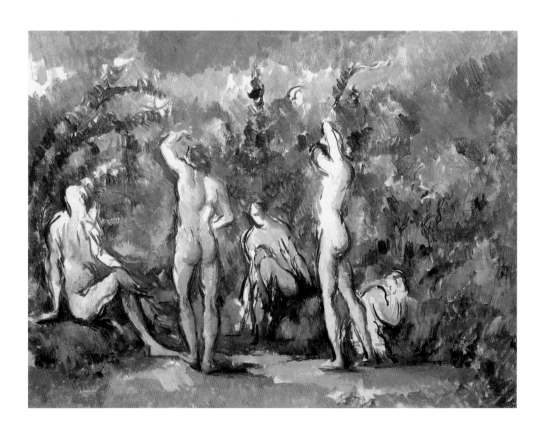

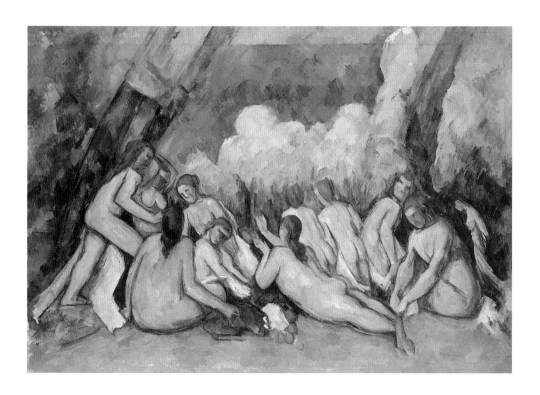

The Large Bathers,
1895-1904

It is quite obvious that Cézanne was little concerned with correct human anatomy. The figure reclining on its stomach not only seems strangely bloated; the lower part of the body also appears disjointed from the torso, with the backbone attached to the left side of the pelvis. The bather striding into the picture from the left has an elongated and muscular thigh. And the seated figure at the right, with its huge upper body, seems almost to have no thighs at all.

Such elongations, foreshortenings, and distortions were employed consciously. Cézanne's treatment of the figure grew logically out of his decision to use certain prototypical human positions in his "Bathers." As the series progressed, these prototypes were increasingly deprived of individuality and reduced to poses, pure and simple. They no longer served to express a certain message or mood, but were treated as forms, no different from those in the landscape, to be integrated in a carefully articulated overall

Bathers,
1896‑97

Still Life with
Pomegranate, 1902 - 06

compositional scheme. This similarity in quality between figures and landscape explains why Cézanne's "Bathers" do not evoke a paradise on earth, a New Arcadia, like that projected in the paintings of, say, the German artist Hans von Marées. Cézanne had no intention of depicting an ideal state, or of invoking a Golden Age in the manner of a classical artist such as Jean Auguste Dominique Ingres. He no longer attempted to translate the idealistic dream of a harmony between man and nature into a realistic image. Cézanne's bathers essentially became things, painted shapes subject to the laws of a pictorial reality determined solely by aesthetic criteria. Not only psychologically, but also in terms of time and space, these figures elude categorization.[25] By making manifest the laws that govern the creation of a painted image, as opposed to the laws of physical reality, Cézanne paved the way for abstraction in art. That, of course, was a development he could not foresee and *The Large Bathers*, with its sleeping black dog and still life of fruit at the bottom of the central axis of the composition, remains indebted to the pastoral tradition.

The treatment of fruit in Cézanne's still lifes bears a strong similarity to that of the figures in his "Bathers." The still lifes, too, do not represent things as seen, with verisimilitude. While the objects generally do possess an almost tangible plasticity, this results not so much from chiaroscuro or an Impressionist play of light and shade, as from the interplay of color. In keeping with his intention to evoke depth through color, Cézanne preferred fruit as a still-life motif, the rounded forms of apples, in particular, suiting perfectly his method of color modulation.

Perhaps the most striking feature of his still lifes, however, is the combination of various perspectives in a single image. Table edges, interrupted by a draped cloth, continue on the other side at a different height; jugs and glasses are frequently depicted simultaneously from a frontal and an elevated point of view; and

Still Life with Ginger Jar and Eggplants, 1893-94

Still Life with Curtain and Flowered Pitcher, 1898-99. Detail opposite

tabletops almost invariably appear tilted upward, toward the viewer. This disregard of traditional perspective reflected Cézanne's extreme concentration on each individual object, which he attempted to depict as exhaustively as possible. In still lifes, as in landscape and figure compositions, then, Cézanne eschewed the principles of visible reality in favor of principles intrinsic to art. In this regard, too, his painting pointed to the future, for its multiple vantage points were to become a key source of inspiration for the multiple perspectives of Cubism.[26]

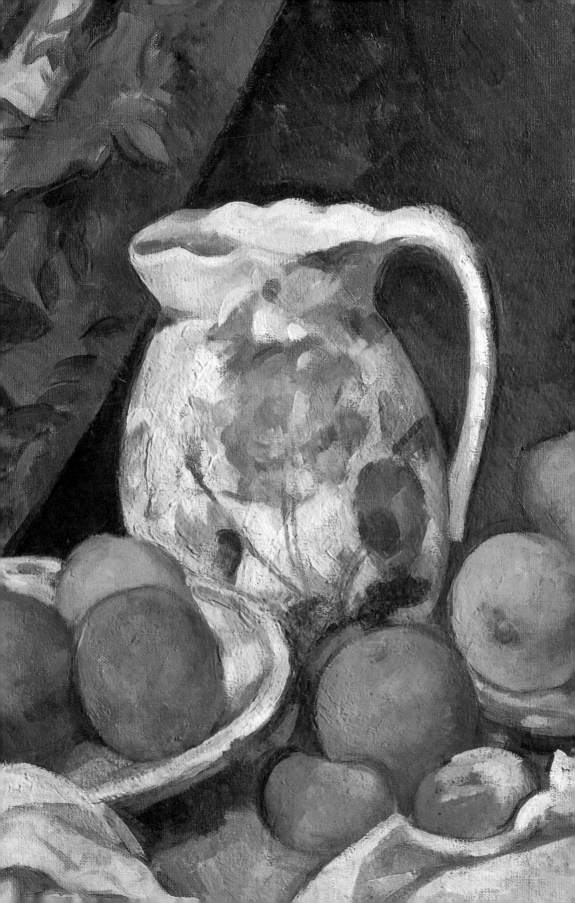

The Jas de Bouffan, 1885-87

Return to Provence:
Cézanne's Favorite Motifs

To achieve success as a painter, Cézanne saw himself compelled to
live occasionally in Paris, where he maintained a studio until the
turn of the century. His love, however, was for the south of France,
where the roots of his art and inspiration lay. Although he suffered
from diabetes, the fact that Cézanne limited himself largely to Aix
and its environs, especially during the last years of his life, cannot
be explained by the state of his health alone.

The main building and the grounds of the Jas de Bouffan were
a virtually inexhaustible source of motifs for the artist. He painted
them from every conceivable angle and, despite the similarity of
many views, he developed each into a unique, homogeneous
image. No matter what configuration of objects Cézanne had be-
fore his eyes, he transformed it into an autonomous entity in paint
on canvas. Instead of working *from* nature, he worked *parallel* to it,
in keeping with his own saying that "Art has a harmony which par-
allels that of nature."[27]

The individual elements of *Jas de Bouffan* (illus. opposite) are
easily identified: on the left, the main façade of the house with its
two rows of tall windows with open shutters; above them, the
mezzanine floor; then, to the right of the house, the farm build-
ings, fronted by a high garden wall. These elements, however,
have been shifted with respect to one another, as if they had
been depicted from different vantage points. The principal diffi-
culty in the view chosen must have been the formal imbalance
between the great mass of the house and the comparatively
small, interlocking shapes of the outbuildings. Yet the sweep of
the garden wall serves to bring the right-hand half of the paint-
ing into balance, while the finely articulated shapes of the build-
ing behind it are stabilized by the horizon line of the hill. Also,
Cézanne's depiction of the main house shows it slightly inclined
to the left, which further contributes to the establishment of a
delicate equilibrium between the two unlike parts of the scene.

By departing from natural appearances to follow aesthetic
principles, Cézanne produced a new type of picture: the painting

as autonomous object. His choice of colors was of considerable significance in this regard. While the left side of *Jas de Bouffan* employs strong color contrasts, dominated by the complementary colors green and red, augmented by sky blue, the right side exhibits a much closer interweaving of gradations. The green hues of the foreground, the reddish ocher of the outbuildings, and the blue of the sky are repeated in the garden wall, just as every color in the left half of the picture reoccurs in the outbuildings and in the hills behind. This engenders a closely knit weave of colors that links the objects in the picture beyond their actual boundaries and establishes interrelationships between complementary colors across the picture plane. By pulling background, middle ground, and foreground together, this use of color lends the depiction a certain flatness, despite the fact that, in the garden wall especially, Cézanne strongly emphasizes three-dimensional qualities. The seemingly random cropping of the view turns out, on closer inspection, to have been thought through down to the tiniest detail.

In *House with Red Roof* (illus. p. 65), too, Cézanne has established unity by means of contrasts. The basic contrast is provided by the motif itself: proliferating vegetation in the foreground, set against the solid, rectangular block of the building, the closed shutters of which give it the appearance of being hermetically sealed off from the surroundings. These two elements are linked by the driveway, which pushes into the middle ground like a wedge, the cast shadows increasing the sense of depth.

While the trees and shrubs, rendered in heavy impasto strokes, are so full of life that they appear on the verge of engulfing the scene, the house looks as static and flat as a stage set in front of a backdrop of diffuse blue sky. The various zones of the picture are also characterized, and set off against one another, by color. The luminous, iridescent greens of the trees and bushes are contrasted to the muted blue of the sky and to the gradations of beige-gray in the house; these, in turn, are repeated in the driveway, which serves to tie the composition together in terms of color.

Once again, Cézanne has succeeded in using systematic contrasts of form and color to engender a harmonious whole. As he himself stated: "To see nature directly consists of sifting out the character of one's subject. To paint something does not mean making a servile copy of it. It means seizing a single harmony out

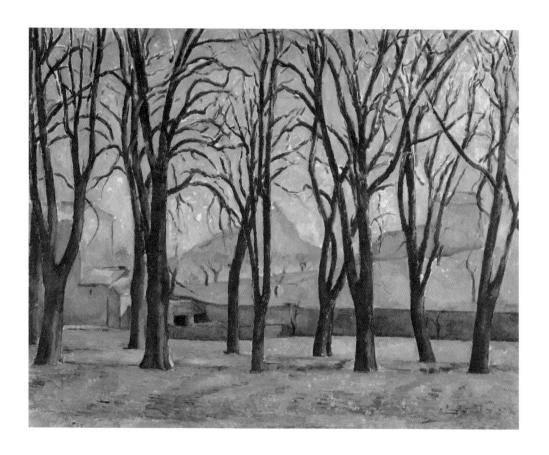

*Chestnut Trees at
the Jas de Bouffan in
Winter, 1885-86*

of all the interconnections one has observed; transposing these into a formal series with its own validity by means of working them up according to a new and original logic."[28]

Although the vantage point adopted for *Chestnut Trees and Farmhouse at the Jas de Bouffan* (illus. p. 64) was only a few yards away from that of *House with Red Roof,* the result, at least on first glance, is a completely different scene. The picture is dominated by two chestnut trees that, almost entirely obscuring the main house, shift the viewer's attention to the adjacent farm buildings. Again, the separate zones of the scene are clearly demarcated. Foreground, middle ground, and background are characterized by fields of subdued color arranged parallel to the picture plane; the beige hues of the outbuildings harmonize with the color gradations in these fields. Depth is suggested by a garden wall leading up to one of the buildings.

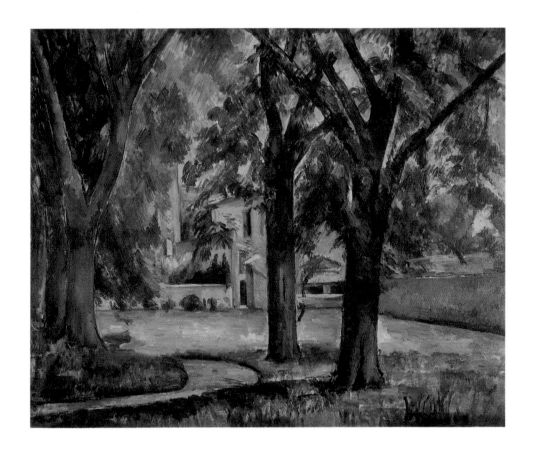

Chestnut Trees and Farmhouse at the Jas de Bouffan, 1885-87

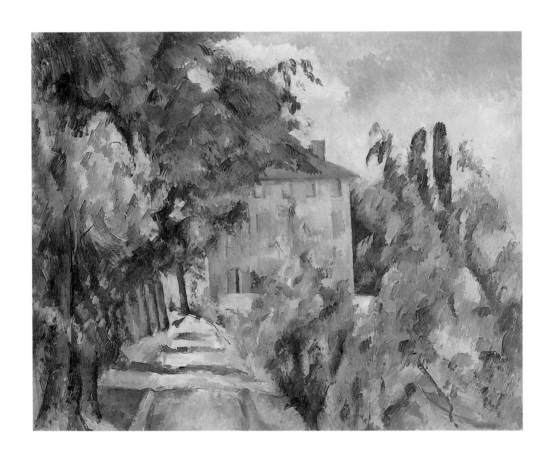

House with Red Roof, ca. 1887

The Pool at the Jas de Bouffan, 1885-90

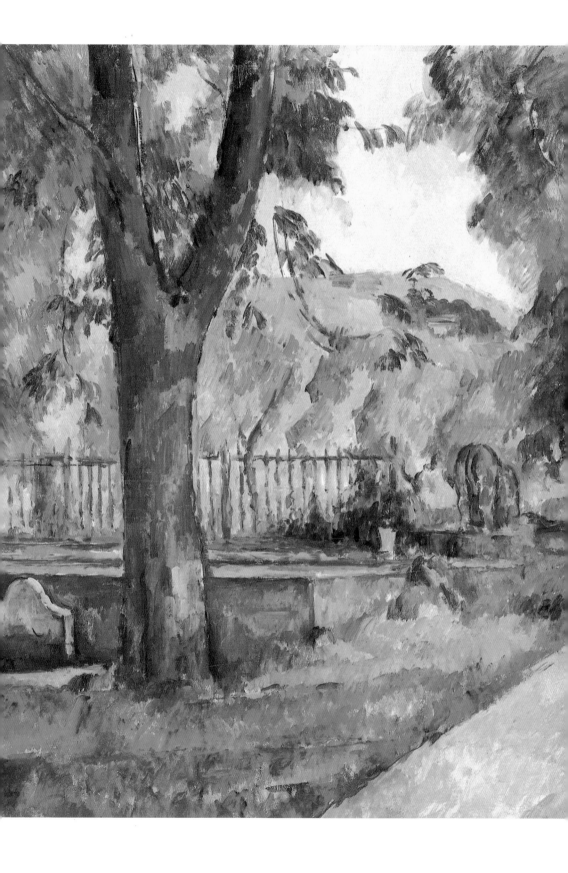

In *The Pool at the Jas de Bouffan* (illus. pp. 66-67), the yard is shaded by tall chestnut trees. In front of the reservoir is a smaller basin where laundry was done and, on its rear right corner, one of the lion-shaped spouts, seen from behind. An atmosphere of intense calm pervades the scene. As in the pictures discussed above, the cropping has an apparently random character and all the zones in the composition are interrelated by means of color repetition, the palette growing lighter toward the background.

Cézanne spent forty years of his life in the Jas de Bouffan, initially with his family—his parents and two sisters, Marie and Rose. Family life there, however, was not always a harmonious affair, as we know from the artist's letters.

The death of Cézanne's father in 1886 had much more far-reaching consequences for the artist's life than his marriage earlier that year. Overnight, he became a well-to-do man and, from that point onward, he spoke of his father with great respect. While his sister Rose, who had married the attorney Maxime Conil in 1881, invested her inheritance in real estate, Cézanne gave little thought to financial matters. Then in his late forties, he appreciated the relaxed atmosphere that now obtained in the house and began to return there at ever shorter intervals. When his mother died in 1897, his sister Marie ran the household, but quarrels over the inheritance soon ensued and, in 1899, the house had to be sold. Cézanne regretted this, but could not prevent it; perhaps he still lacked the self-confidence to stand up to his family.

The problems of family life served only to increase the attraction of the environs of Aix and the Mediterranean coast for Cézanne. For a long time L'Estaque was his favorite enclave. He first went there in 1864, but this sojourn is not reflected in his work, since landscape interested him little at that time. After his second visit, in 1870, Cézanne returned frequently to L'Estaque until 1888. Zola described the town in one of his novels:

> A village just outside of Marseille, in the center of an alley of rocks that close the cliff-lined bay. The country is superb. The arms of rock stretch out on either side of the gulf, while the islands, extending in width, seem to bar the horizon, and the sea is but a vast basin, a lake of brilliant blue when the weather is fine. At the foot of the mountains the houses of Marseille are seen on different levels of the low hills;

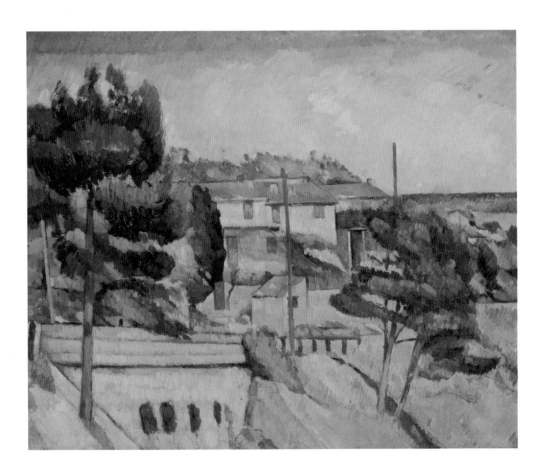

*The Rail Viaduct at
L'Estaque,* 1883

when the air is clear one can see, from L'Estaque, the gray Joliette breakwater and the thin masts of the vessels in the port. Behind this may be seen, high on a hill, surrounded by trees, the white chapel of Notre-Dame de la Garde. The coastline becomes rounded near Marseille and is scooped out in wide indentations before reaching L'Estaque; it is bordered with factories that sometimes let out high plumes of smoke. When the sun falls perpendicularly to the horizon, the sea, almost black, seems to sleep between the two promontories of rocks whose whiteness is relieved by yellow and brown. The pines dot the red earth with green. It is a vast panorama, a corner of the Orient rising up in the blinding vibration of the day.

But L'Estaque does not only offer an outlet to the sea. The village, its back against the mountains, is traversed by roads that disappear in the midst of a chaos of jagged rocks. . . . Nothing equals the wild majes-

69

ty of these gorges hollowed out between the hills, narrow paths twisting at the bottom of an abyss, arid slopes covered with pines and with walls the color of rust and blood. Sometimes the defiles widen, a thin field of olive trees occupies the hollow of a valley, a hidden house shows its painted façade with closed shutters. Then, again, paths full of brambles, impenetrable thickets, piles of stones, dried-up streams, all the surprises of a walk in the desert. High up, above the black border of the pines, is placed the endless band of the blue silk of the sky.

And there is also the narrow coast between the rocks and the sea, the red earth where the brickworks, the big industry of the district, have excavated large holes to extract clay.... One would think one were walking on roads made of plaster, for one sinks in ankle-deep; and, at the slightest gust of wind, great clouds of dust powder the hedges....When this dried-out country gets thoroughly wet, it takes on colors ... of great violence: the red earth bleeds, the pines have an emerald reflection, the rocks are bright with the whiteness of fresh laundry.[29]

Cézanne saw L'Estaque with a far more sober eye than Zola. To the artist, it presented "some very beautiful views,"[30] which he proceeded to depict in variation after variation. Made temporarily famous by the Cubists Pablo Picasso and Georges Braque around 1908,[31] L'Estaque has since become a relatively insignificant industrial suburb of Marseille, dominated, as in Cézanne's time, by brickmaking enterprises. The fishing boats that used to dot the beach have made way for yachts, but the rugged limestone cliffs are as majestic as ever and they attract crowds of recreation-seekers from town.

The cliffs figure prominently in many of Cézanne's compositions. *The Sea at L'Estaque* (illus. pp. 48-49), dating from 1878-79 and acquired by Picasso in the 1940s, was painted from the vantage point of a mountain path that offered a view of the sea over the village below. The resulting tripartite stratification of the composition was to remain typical of the artist's subsequent views of L'Estaque. In the near foreground, almost at the viewer's feet, a tree-lined path leads into the picture. The trunks frame the motif proper and also serve as transitions to the other zones of the composition. From the high vantage point we look down the slope to the village nestled against it. The houses are simplified to cubic shapes and their brick-red roofs are contrasted to the green vegetation. An impression of depth is engendered by the diagonal of

View of L'Estaque and the Château d'If, 1883-85

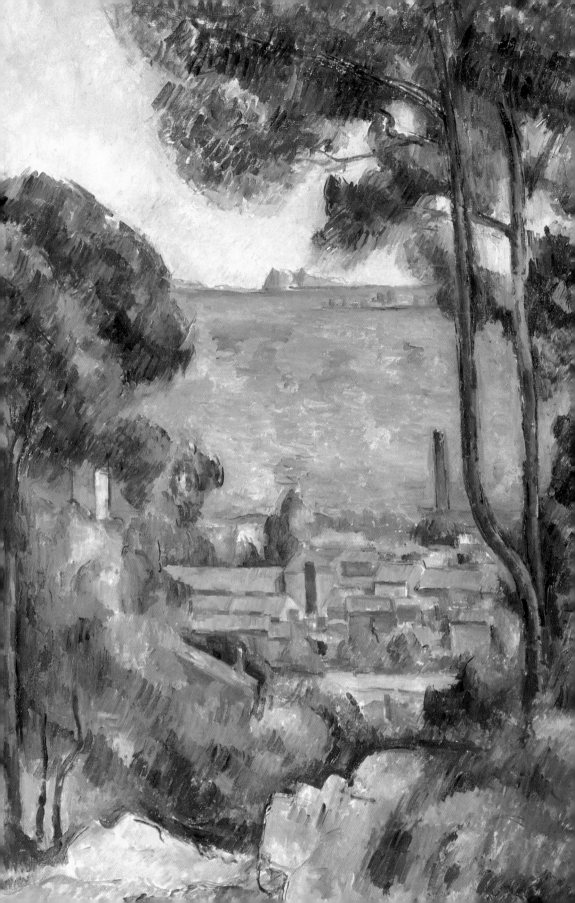

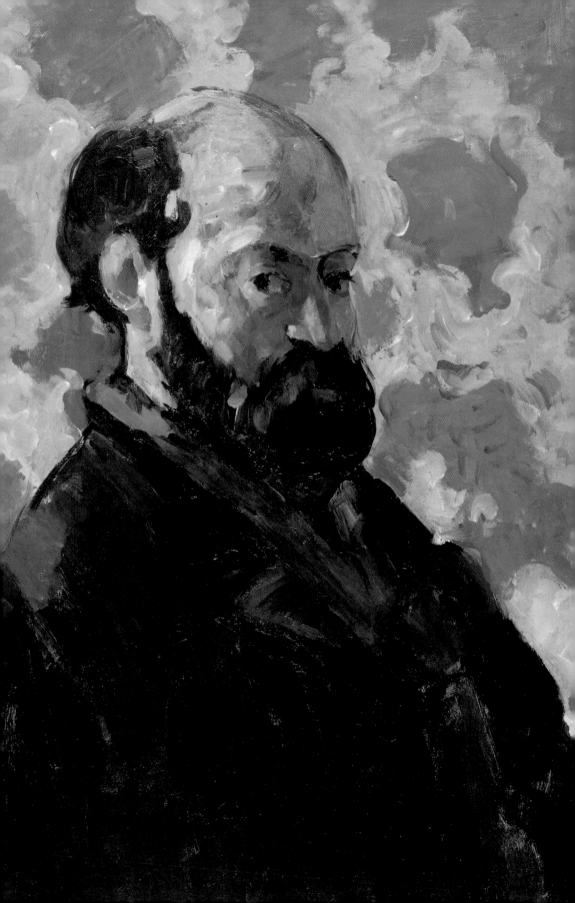

Paul Cézanne, ca. 1875

the slope. The composition is based on a rigorous scheme of verticals and horizontals, the verticals of trees and chimney braced by the horizontals of path and horizon. Yet the stringency is relaxed by means of two intersecting diagonals: that of the slope and that of the tree leaning into the picture from right to left.

Writing to his young friend and fellow artist Emile Bernard, Cézanne explained his approach to composition very clearly: "Treat nature by means of the cylinder, the sphere, and the cone, everything brought into proper perspective so that each side of an object or a plane is directed toward a central point. Lines parallel to the horizon give breadth... a section of nature... lines perpendicular to the horizon give depth. But nature for us men is more depth than surface, whence the need to introduce into our light vibrations, represented by the reds and yellows, a sufficient amount of blueness to give the feel of air."[32]

In *View of L'Estaque and the Château d'If* (illus. p. 71) the cubically simplified houses lie in a plain, with a steep slope leading down to them. Visible in the background, off the coast, is the Château d'If. Built in 1524 as a fort to protect the town and harbor, the

Self-Portrait with Pink Background, ca. 1875

73

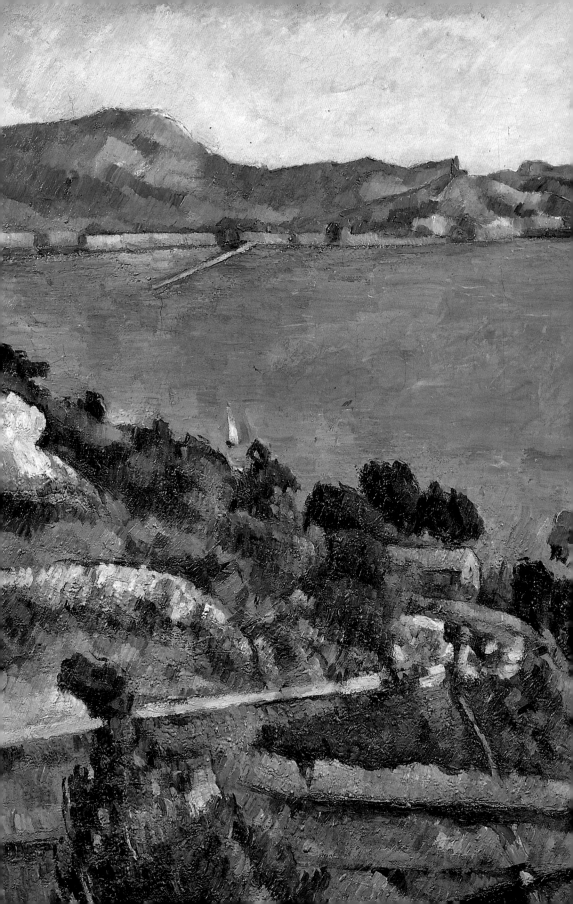

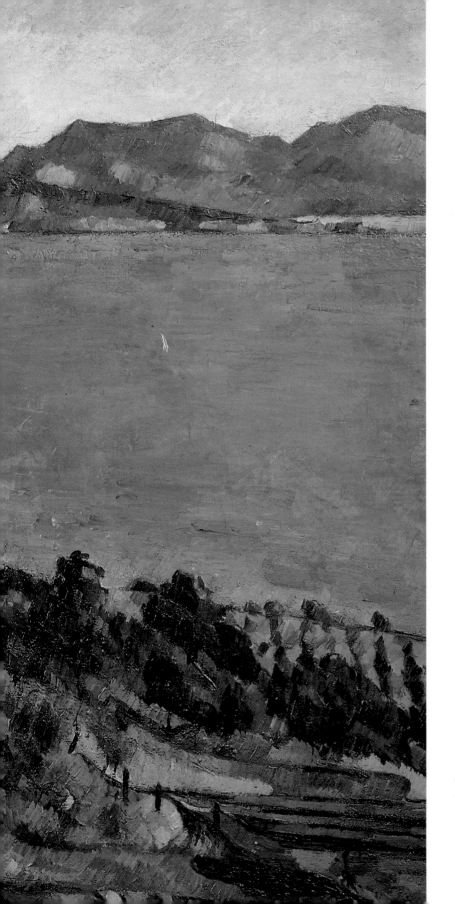

L'Estaque,
1878- 79

building was converted a short time later into a state penitentiary for political prisoners.

In the 1880s Cézanne decided to settle permanently in L'Estaque. "I shall not return to Paris before next year," he wrote to Zola on May 24, 1883. "I have rented a little house and garden at L'Estaque just above the station and at the foot of the hill where, behind me, the rocks and the pines rise. I am still busy painting."[33]

As the years passed and the area took on an increasingly industrial character, Cézanne began to avoid what had been one of his favorite places. Looking back, he explained his decision in a letter

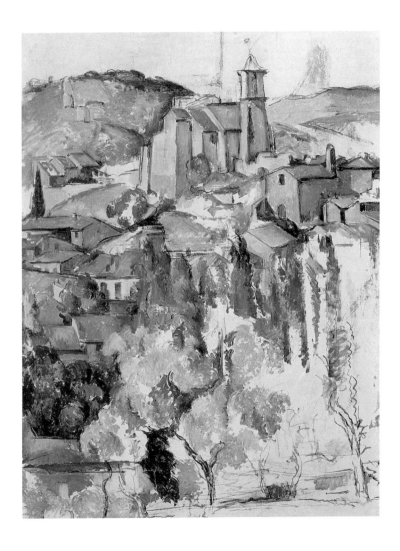

Gardanne, 1885-86

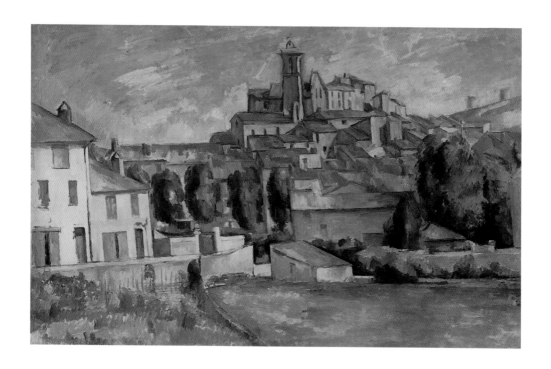

Gardanne, 1885-86

of 1902 to his godchild, Paulette Conil: "I remember perfectly well the Establon and the once so picturesque banks of L'Estaque. Unfortunately, what we call progress is nothing but the invasion of bipeds who do not rest until they have transformed everything into hideous *quais* with gas lamps—and, what is still worse—with electric illumination. What times we live in!"[34]

After the mysterious love affair of spring 1885—the only clue to which is found in one of his letters—Cézanne did not return to Aix until the following August. He began to make daily trips to Gardanne, a small town some eleven miles to the southwest. *Gardanne* (illus. p. 77) is dominated by an unusual arrangement of houses, which rise like stepping-stones up a low hill, topped by a church with tall towers. The layout of the town must have appealed greatly to Cézanne, for he decided to move there with Hortense and Paul. His depictions of it, characterized by distant vantage points, stringent compositions, and a reduction of forms to their architectonic essentials, are among those works of his that anticipate Cubism most clearly.

Another of Cézanne's favorite places in the 1880s was the Bellevue estate, where his sister Rose and her husband, Maxime Conil, resided from 1881 on. It was located west of Aix, on a rise that offered a beautiful view of the Arc Valley (see illus. pp. 88-89). From this vantage point Cézanne painted a number of landscapes, most of them with Mont Sainte-Victoire in the background. As at the Jas de Bouffan, he could be assured that, with the possible exception of one of the few inhabitants, no human soul would disturb him while he worked.

Aix continued to induce the same antipathy in Cézanne that he had felt as a young man. The town was provincial in the worst sense and yet he could not resist the urge to return again and again. "When I was at Aix," he wrote on one occasion, "it seemed to me that I should be better elsewhere, now that I am here [at Talloires], I think with regret of Aix. Life for me is beginning to be of a sepulchral monotony."[35]

When the Jas de Bouffan was sold in 1899, Cézanne moved into a small apartment in Aix, at 23, rue Boulegon. As his wife and son lived primarily in Paris, he hired a housekeeper, Madame Brémond. Back in 1881, tired of living alone, Cézanne had compelled Hortense and Paul to move to Aix, but the inevitable tensions soon arose between his wife and his relatives. Also, Hortense found Aix far too rustic for her taste, and soon moved back to Paris.

Misanthropy, personal disappointments, and over-sensitiveness combined to make Cézanne increasingly eccentric. The older he grew, the deeper became his distaste for change of any sort, especially in his home town of Aix. He once told Jules Borély:

I was born here; I shall die here. I left town when I finished school, to go to Paris, and twenty-one years later I didn't even recognize it—the faces of the girls I saw before I left had changed too much. Nowadays everything changes in reality, but not for me; I live in the town of my childhood, and it is in the eyes of people of my age that I see the past. What I love more than anything else is the look of people who have grown old without doing violence to manners by accepting the laws of the age. I hate the effects of these laws. Look at that café proprietor, sitting in front of his door under that spindle-tree—what style! Or look at that salesgirl in the square—surely she's nice, and one shouldn't say anything bad about her. Still, her hairdo, her dress—how banal and false![36]

This conservatism, supplemented in old age by practicing Catholicism, cannot be attributed to provincial narrow-mindedness. It resulted from Cézanne's incessant search for truth and his belief in eternal values, and also from that status of social outsider which is often the lot of a critical mind. In addition, Cézanne had had to suffer years and years of attacks on his painting and continual rejection on the part of the Salon: "If the official Salons remain so inferior, the reason is that they encourage only more or less widely accepted methods," he wrote to Emile Bernard in 1905. "It would be better to bring in more personal emotion, observation, and character. The Louvre is the book in which we learn to read. We must not, however, be satisfied with retaining the beautiful formulas of our illustrious predecessors. Let us go forth to study beautiful nature, let us try to free our minds from them, let us strive to express ourselves according to our per-

Large Pine and Red Earth, ca. 1895

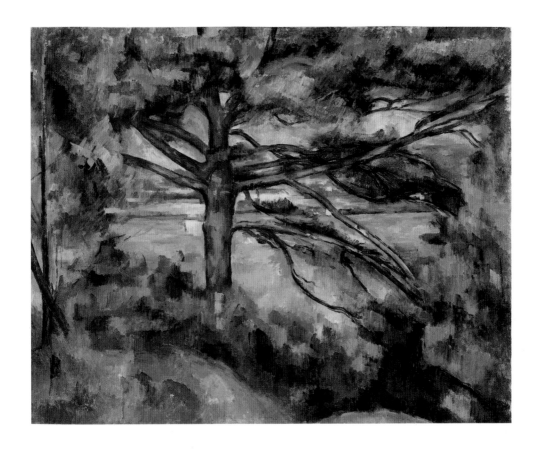

sonal temperament. Time and reflection, moreover, modify little by little our vision, and at last comprehension comes to us."[37]

When his significance was at last recognized by younger artists, such as Maurice Denis and Paul Gauguin, the aging Cézanne was no longer capable of making new contacts or entering new relationships. For that, he was evidently still too deeply involved in the mental world of his youth. Cézanne maintained contacts with only a very few trusted intimates. Apart from his son, Paul, he kept up a lively correspondence with Emile Bernard, to whom we owe significant insights into Cézanne's approach to art.

Escaping the town as often as he could, Cézanne finally purchased, in November 1901, a lot on the Chemin des Lauves, in the hills north of Aix. He had a studio built to his specifications, which was finished in September 1902. The studio building had two floors: a ground floor divided into several small rooms and an upper floor, the studio proper, just under six hundred square feet in area and about seventeen feet high. Two windows in the south wall overlooked Aix; a third window illuminated the stairwell. The north wall consisted of a huge expanse of glass, providing ideal studio lighting. The house was fronted by a terrace about twenty feet wide; a low wall separated this from the garden, the workplace of Cézanne's last sitter (see illus. p. 99).

Today, the building, to which an annex has been added, houses a museum. The studio room is exactly as the artist left it. The paths Cézanne followed in his search for motifs have been developed into a tourist itinerary, the Route Cézanne.[38] Beginning in Aix, the route leads eastward in the direction of Le Tholonet, a village about three miles distant. Following the twisting road toward Mont Sainte-Victoire, one comes, on the left, to a path that snakes up a gentle incline into the woods. This path led past boulders and millwheels (see illus. p. 82) to a deserted house (see illus. p. 83), where a splendid view of the west wing of the Château Noir opened out.

Located about midway between Aix and Le Tholonet, the ruined neo-Gothic château was erected for a coal dealer in the second half of the nineteenth century. It comprises two separate buildings, at right angles to one another: the main building to the south, overlooking the road and valley, and the auxiliary building

Large Pine and Red Earth, ca. 1895. Detail

80

to the west. Extending between them was a row of columns, intended for an orangery that was never completed. Functionless, the colonnade lent the entire scene the mood of a Romantic painting of ruins. The garden, even when Cézanne saw it, was a virgin wilderness with trees and shrubs growing out of bizarre rock formations—for the artist, a virtually inexhaustible source of motifs.

The Château Noir was the subject of many a tale and legend. Its owner had it painted black, the rumor went, because he was an alchemist and in league with the devil—a story that indicates how eerie the unfinished house on the hill must have looked. After the sale of the Jas de Bouffan, Cézanne tried in vain to buy the Château Noir, which stood empty most of the year. He was apparently fascinated by the mystical aura of the place, for he emphasized this in his paintings (see illus. pp. 84-85).

Woods with a
Millstone, 1892-94

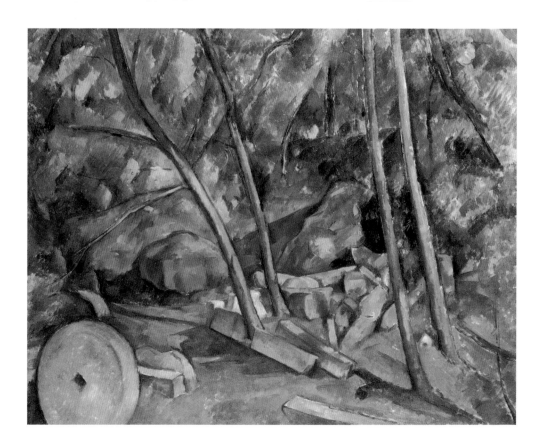

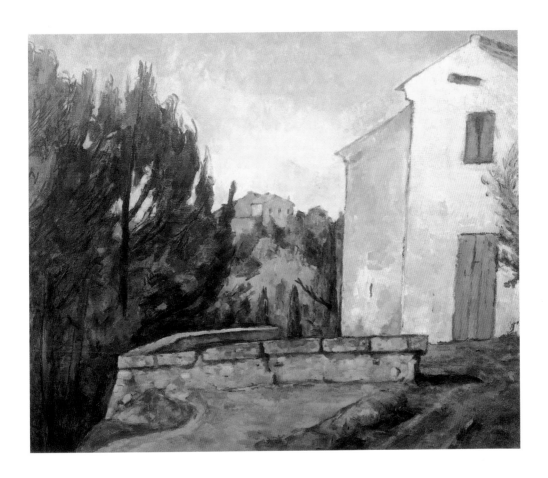

The Abandoned House at Le Tholonet, 1878-79

Similarly fascinating for Cézanne was the Bibémus quarry—reached by a road north of the Château Noir—which had lain abandoned for some years. There he rented a small, isolated cottage—a *cabanon*—to store his painting utensils. The unusual rock formations, created by the workings of human hands, were overgrown with bushes and trees, presenting the strong contrasts of form and color that Cézanne favored.

The Château Noir, 1904-06

Mont Sainte-Victoire:
Apotheosis of the Landscape

"Only there is the plain, rough, and gentle beauty of our Provence to be met with,"[39] wrote Gasquet in 1896 of the countryside around Mont Sainte-Victoire.

Approaching Aix-en-Provence, one's eye is immediately drawn to a mountain chain cutting across the plain in a northeastern direction. The massive, majestic peak of Mont Sainte-Victoire, soaring to a height of over three thousand feet, dominates the entire region. It seems quite natural that Cézanne should have found in the mountain the fulfillment of his longing for a symbol of the "authentic" Provence. The works he devoted to it contain his perception of nature in its purest form.

The mountain was first named by the Ligurians and Celts, who called it Ventour, after their god of the winds. Its caves and grottoes had, as artifacts found there indicate, already been used for cultic rites in the prehistoric era. From the fifth century, and especially during the Christianization of the region, hermits settled on the mountain, which was considered a dwelling of the saints. A Romanesque church, built over the grotto of Saint-Ser, was still a pilgrimage place for marriageable girls and for mothers with ailing children in Cézanne's day.

The Christians renamed the mountain Santa Ventura. In the seventeenth century, monks of the Camaldolese order erected a monastery there that served as a haven for weary travelers. The mountain acquired its present name in the nineteenth century, in commemoration of the legendary victories of the Romans, led by Marius, over the invading Teutons (102 B.C.) and Cimbrians (101 B.C.).

Cézanne was familiar with Mont Sainte-Victoire from an early age. He frequently explored the mountain on his youthful expeditions into the countryside around Aix and he no doubt took part in the annual celebrations on its peak, when the St. John's Fire was lit to mark an important Provençal holiday. Mont Sainte-Victoire first appeared in his work in *Railroad Cutting* (illus. pp. 42-43). Throughout the artist's early period the mountain con-

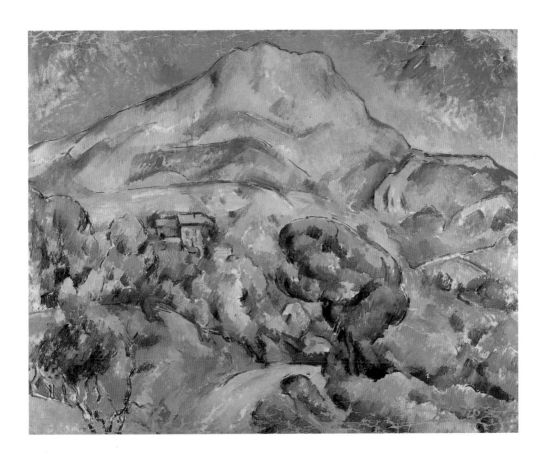

Mont Sainte-Victoire
Seen from the Road to
Le Tholonet, 1896-98

tinued to serve mostly as a background motif in landscapes and figure compositions; later, in the 1890s, it became the dominant feature, the central focus of sweeping panoramas.

Since time immemorial, prominent mountain peaks have been associated with the divine and the numinous: Mount Olympus, Mount Ararat, and Mount Sinai spring to mind as examples. Mont Sainte-Victoire was no exception and, not surprisingly, the sacred aura that surrounded it entered Cézanne's paintings. Yet, for him, the mountain also embodied the happy days of his youth and it figured in his mind as a symbol of harmony and permanence. In over thirty oils and forty-five watercolors he depicted it from a great variety of vantage points—frontally, from the side, close up, from a distance—creating in every case a new impression of the landscape.

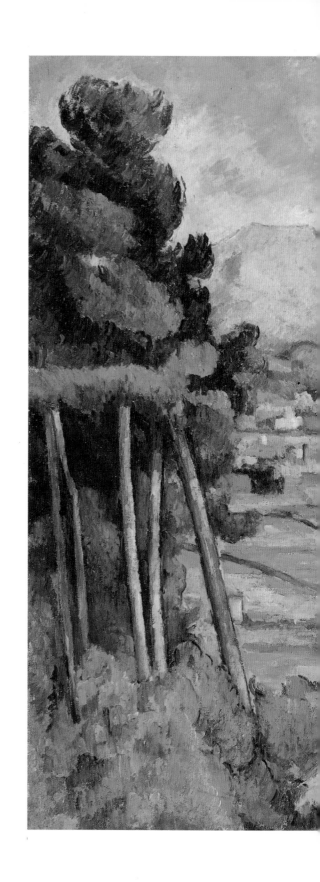

Mont Sainte-Victoire Seen from Bellevue,
1882-85

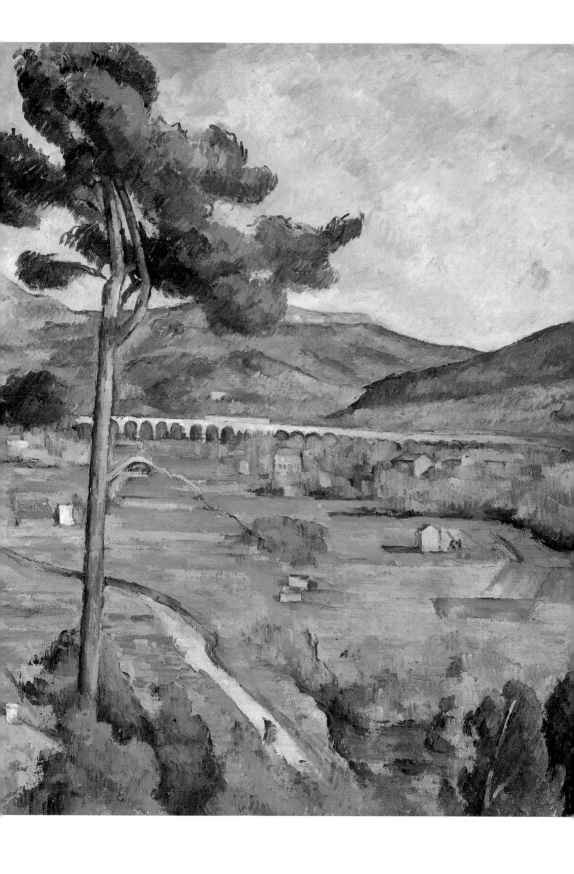

Seen from Bellevue, the farm owned by Cézanne's brother-in-law, Mont Sainte-Victoire looked down on the broad valley of the Arc River (see illus. pp. 88-89). "Progress," in the form of a railroad viaduct, had left its mark on this view from the southwest.

When Cézanne looked at the mountain from Gardanne, in order to depict its southern elevation, he saw a chain of hills extending behind a landscape with relatively sparse vegetation. The true principal motif in this case were the houses, which the artist reduced to simple, cubic forms that lent them a rather forbidding aspect.

The views from the rue de Tholonet (see illus. p. 87) and from Bibémus quarry brought Mont Sainte-Victoire into the compositional center of interest. No path leading into the picture, no groups of trees, interposed themselves between spectator and mountain. Majestic and alone, the peak now dominated the closely cropped scene.

In the years 1902 to 1906, from his new studio on the Chemin des Lauves, Cézanne produced a final series of images of Mont Sainte-Victoire. In these compositions (see illus. pp. 92-93) the eye glides from a narrow foreground zone of green over a wide, flat plain, to be brought up abruptly by the walls of the mountain with its conical peak. The multicolored weave of patches of color in the middle ground, created by means of a vigorous interplay of broad brushstrokes, thin hatchings, and carefully placed, small, flat planes, links foreground, middle ground, and background by repeating the hues of the meadows and olive trees and the crystalline blues of the mountain. In this culmination of Cézanne's painting technique the motif often all but disappears in an intricate mass of color gradations and paint layers.

The idea that landscapes consisted of a fabric of colored patches arose from Cézanne's theory of perception. According to this theory, the eye perceives not objects and their individual characteristics, but "taches colorées," patches of color that the mind immediately translates into a logical framework. Cézanne distinguished between seen and recognized reality and limited himself to recording the actual process of vision; that is, he tried to expunge from his mind all knowledge about the things that he saw and to depict only the color impressions—or "sensations," as he called them—that those things made on his eye. In so doing,

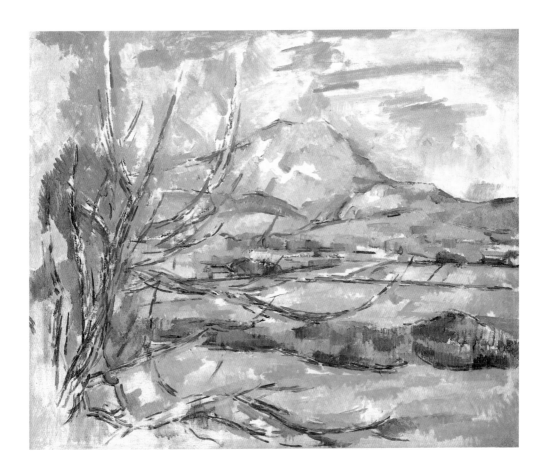

Mont Sainte-Victoire,
1900-02

Cézanne took a step into new perceptual realms: "Now, being old, nearly 70 years, the sensations of color, which give the light, are for me the reason for the abstractions which do not allow me to cover my canvas entirely nor to pursue the delimitation of the objects where their points of contact are fine and delicate; from which it results that my image or picture is incomplete."[40]

His first experiments in this new principle of color composition were made in the watercolor medium. Cézanne himself called the approach "modulation," a musical term that denotes the transition from one key to another.

Very few people were allowed to watch the artist paint. One of them was Emile Bernard, who described the way in which Cézanne developed an image:

Mont Sainte-Victoire
Seen from Les Lauves,
1902 - 06

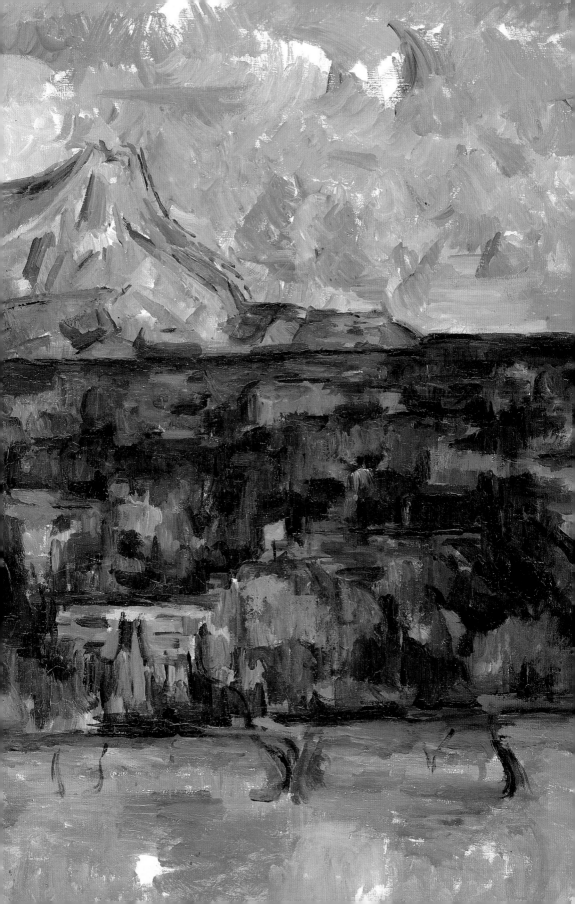

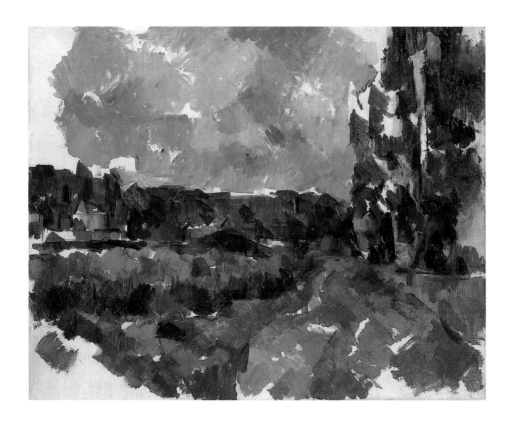

Banks of a River, 1904-05

Mont Sainte-Victoire, 1904-06

Banks of a River, 1904-05

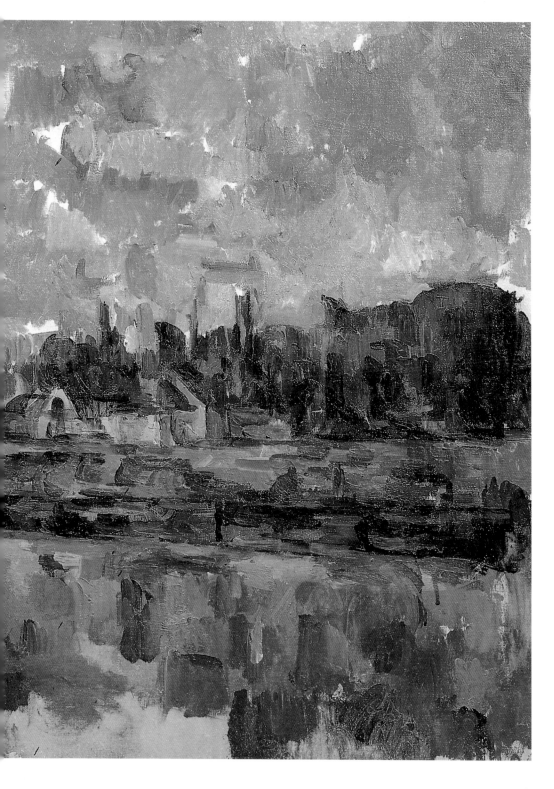

His method was remarkable, absolutely different from the usual way and excessively complicated. He began on the shadow with a single patch, which he then overlapped with a second, and a third, until these hues, hinging to one another, not only colored the object, but also molded its form. I realized then that it was a law of harmony that directed his work and that the course these modulations took was fixed beforehand in his mind. In short, he proceeded in the way that must have been taken by the old tapestry makers, making related colors follow one another to the point at which opposing contrasts met. But then I sensed that a procedure like this, applied to nature, produced a sort of contradiction, for any rational formula adapts more readily and more easily to an artificial entity than to a natural motif. Observing nature with a child's freshness of vision would mean having no fixed preconceptions, and proceeding without deliberation—doing nothing, that is to say, but observe and record.[41]

Like the geological strata of a mountain—a subject in which the artist was keenly interested—the crystalline color patches in Cézanne's paintings corresponded to an internal structure. He explained to Gasquet:

There mustn't be a single slack link, a single gap through which the emotion, the light, the truth can escape. I advance all of my canvas at one time, if you see what I mean. And in the same movement, with the same conviction, I approach all the scattered pieces.... Everything we look at disperses and vanishes, doesn't it? Nature is always the same, and yet its appearance is always changing. It is our business as artists to convey the thrill of nature's permanence along with the elements and the appearance of all its changes. Painting must give us the flavor of nature's eternity. Everything, you understand. So I join together nature's straying hands.... From all sides, here, there, and everywhere, I select colors, tones, and shades; I set them down, I bring them together.... They make lines. They become objects— rocks, trees—without my thinking about them. They take on volume, value. If, as I perceive them, these volumes and values correspond on my canvas to the planes and patches of color that lie before me, that appear to my eyes, well then, my canvas "joins hands." It holds firm. It aims neither too high nor too low. It's true, dense, full.... But if there is the slightest distraction, the slightest hitch, above all if I interpret too much one day, if I'm carried away today by a theory which contradicts yesterday's, if I think while I'm painting, if I meddle, then whoosh!, everything goes to pieces.[42]

The Gardener Vallier,
1906

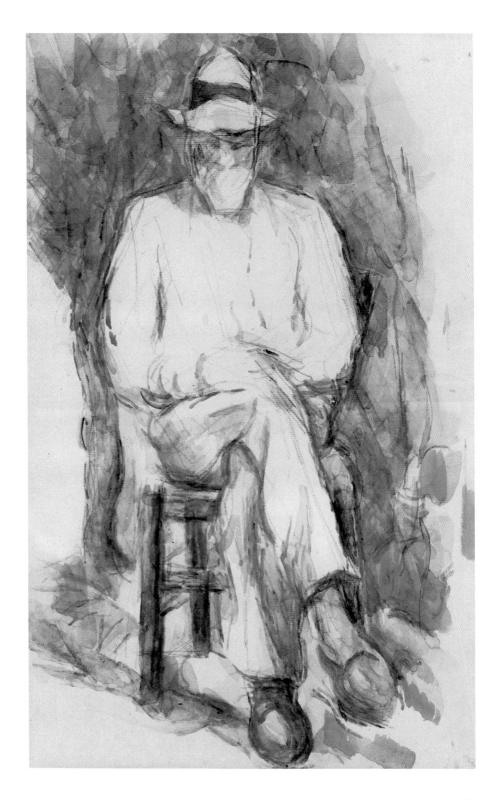

The Cabanon de Jourdan, 1906

Since Cézanne painted very slowly, Mont Sainte-Victoire was the ideal motif. He walked around it again and again, observing and depicting it from every angle. During the last years of his life, the artist devoted himself to the mountain with passionate intensity. In addition to its associations with his happy childhood, Mont Sainte-Victoire now became the prime symbol of Cézanne's philosophy of nature. "Look at Sainte-Victoire there," he enjoined Gasquet. "How it soars, how imperiously it thirsts for the sun! And how melancholy it is in the evening when all its weight sinks back.... Those blocks were made of fire and there's still fire in them. During the day shadows seem to creep back with a shiver, as if afraid of them."[43]

On October 15, 1906, Cézanne set out on his daily search for motifs. For seven years now he had hardly left Aix and had concentrated almost exclusively on landscapes and portraits. His destination that day was probably Jourdan's *cabanon*, a subject he had turned to recently (see illus. p. 100).

"It has rained a lot," Cézanne wrote to his son Paul, "and I think that this time the heat is over. As the banks of the river are

now a bit cool, I have left them and climb up to the quartier de Beauregard, where the path is steep, very picturesque, but rather exposed to the mistral. At the moment, I go up on foot with only my bag of watercolors, postponing oil painting until I have found a place to put my baggage; in former times one could get that for 30 francs a year. I can feel exploitation everywhere."[44]

When a storm came on, Cézanne had to pack up and start for home. Physically frail and burdened with his painting utensils, he soon began to find the walk an ordeal. The struggle against wind and rain overtaxed his constitution and, on the road to Aix, he grew giddy and fainted. It is not known how long he had lain at the side of the road when the laundry cart from Aix chanced upon him. The drivers recognized him and took him home. Exposure, the doctor said, had brought about a chill—no cause for concern. The next morning Cézanne got up as usual and went to work at an early hour, continuing a portrait of his gardener, Vallier. As his sister Marie reported to her nephew a few days later, Cézanne came home that night deathly ill. He was never to leave his bed again.

Yet his urge to work remained unbroken. On October 17 he wrote to his art supplier for ten tubes of paint; but his body would no longer obey his iron will. On October 22, 1906, Paul Cézanne died, without having seen his family again. Paul Jr. and his mother had not heard of his illness until Marie's letter arrived. Hortense reputedly withheld from her son a telegram received on the 21st. So Cézanne died a lonely man, but he had contracted his fatal illness while out painting, "sur le motif"—and that is how he had always wished to die.

Biographical Notes

1839
January 19: Paul Cézanne is born at 28, rue de l'Opéra, Aix-en-Provence. He is the first child of Louis-Auguste Cézanne (1798- 1886) and Anne-Elisabeth-Honorine Aubert (1814- 1897).

1841
July 4: Birth of his sister Marie at their father's residence, 55, cours Mirabeau, in Aix.

1844
January 29: His parents are married. Paul attends elementary school until 1849.

1848
June 1: His father establishes the Banque Cézanne & Cabassol.

1849
Is enrolled in the Ecole de Saint-Joseph, which he attends until 1852.

1852
Transfers to the prestigious Collège Bourbon, where he meets Emile Zola (1840- 1902).

1854
June 30: His sister Rose is born in Aix, at 14, rue Matheron.

1857
Takes drawing courses at the Ecole Spéciale et Gratuite de Dessin until 1862.

1858
February: Zola moves with his mother to Paris. November 12: Paul passes his final school examinations on the second try. Takes drawing instruction from Joseph Gibert at the Musée Granet, Aix, until 1862.

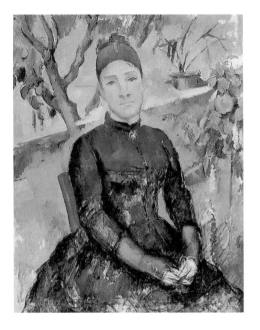

Madame Cézanne in the Conservatory, 1891- 92

Facing page:
Self-Portrait with Turquoise Background, ca. 1885

1859
Begins law studies in Aix, at his father's behest. Louis-Auguste buys a country house, the Jas de Bouffan, and frees his son from military service by paying a man to substitute for him.

1860
Cézanne decorates the walls of the grand salon at the Jas de Bouffan with allegorical scenes and begins to devote more and more of his time to painting.

1861

Abandons his law studies. April 22: Arrives in Paris, enrolling at the Académie Suisse, where he meets Camille Pissarro (1830-1903). That September, doubting his talent, Cézanne returns to Aix and takes a job at his father's bank.

1862

Installs a studio at the Jas de Bouffan. In January, resisting his father's wishes once again, Cézanne leaves the bank to devote himself entirely to painting. That November he travels to Paris, where he applies to enter the Ecole des Beaux-Arts, but is not accepted. His father grants him a monthly allowance of 150 francs.

1863

Resumes life classes at the Académie Suisse and shows a still life at the Salon des Refusés. Lives at 7, rue des Feuillantines.

Paul Cézanne (center) with Camille Pissarro (right) near Auvers, ca. 1874

Marie Cézanne, one of the artist's sisters, ca. 1870

1864

Makes copies of pictures by Eugène Delacroix and Nicolas Poussin in the Louvre. Submits paintings to the official Salon, which are rejected. Lives from July to the end of the year in Aix, where he meets Antoine Fortuné Marion, a young geologist. Spends that August in L'Estaque, on the Bay of Marseille.

1865

Returns to Paris, where he lives at 22, rue Beautreillis. Spends that autumn in Aix.

1866

Cézanne's works are again rejected by the Salon. Spends July with Zola in Bennecourt on the Seine, and then returns in August to Aix, where he remains until December.

1867

Apart from a summer trip to Aix, Cézanne lives in Paris.

1868
Works from May to December in Aix.

1869
Early in the year Cézanne meets Hortense Fiquet, a nineteen-year-old bookbinder who works part time as an artists' model.

1870
Until July, lives in Paris, at 53, rue Notre-Dame-des-Champs. May 31: Serves as witness at Zola's wedding. July 18: With the Franco-Prussian War impending, Cézanne travels with Hortense to L'Estaque, in the hope of avoiding conscription. His father retires at age 72.

1871
Cézanne works in L'Estaque until March, cut off from political events. Then he goes to Aix and, in the autumn, to Paris, where he lives at 5, rue de Chevreuse and, from December, at 45, rue de Jussieu.

1872
January 4: His son, Paul, is born. In the autumn, Cézanne moves with his family to Saint-Ouen-l'Aumône on the Oise River, across from Pointoise, northwest of Paris, where he paints with Pissarro. At the end of the year, he, Hortense, and Paul move to Auvers-sur-Oise, where they will remain until spring 1874.

Paul Cézanne
(seated on the left) with
Camille Pissarro
(standing on the right)
and friends in Pontoise,
1877

Cézanne's studio on the Chemin des Lauves, ca. 1904

Cézanne in his studio on the Chemin des Lauves, 1894

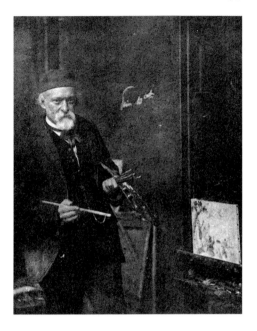

1873
Makes a few etchings in Auvers. Collaborates with Pissarro. Meets Vincent van Gogh (1853 - 1890).

1874
That spring, Cézanne returns to Paris. April 15 to May 15: Shows three paintings (*The Maison du Pendu, View of Auvers*, and *A Modern Olympia*) in the first group exhibition of the "Société anonyme des artistes, peintres, sculpteurs, graveurs"—the Impressionists—which is held in the studio of the photographer Nadar. Returns to Aix in June and, from September, lives in Paris, at 120, rue de Vaugirard.

1875
Makes the acquaintance of Victor Chocquet, a collector who had purchased one of Cézanne's canvases from the paint dealer Père Tanguy. Second Impressionist exhibition. Cézanne moves to 15, quai d'Anjou.

1876
Lives from April to July in Aix and L'Estaque; returns to Paris in August.

1877
Staying in Paris primarily at 67, rue de l'Ouest, Cézanne is represented at the third Impressionist exhibition with fourteen oils and three watercolors. The critics again reject his work. Paints with Pissarro in Pontoise, then by himself in Issy, near Paris.

1878
Spends March in L'Estaque, April to June in Aix, then July to the end of the year in L'Estaque. Hortense and Paul Jr. live in Marseille, where Cézanne visits them. He accepts financial support from Zola, who has bought a house in Médan, on the Seine northwest of Paris.

1879
Leaves L'Estaque in April. Resides in Melun, outside Paris, until spring 1880. Visits Zola in Médan in the autumn.

1880

Lives in Paris, at 32, rue de l'Ouest, from March through to April of the following year. Spends part of the autumn months with Zola in Médan.

1881

Works from May to October with Pissarro in Pontoise, where he meets Paul Gauguin (1848-1903), then returns to Paris. Spends November in Aix.

1882

In February, paints in L'Estaque, where Auguste Renoir (1841-1919) visits him. Spends March to September in Paris. A Cézanne portrait, ostensibly done by a "pupil of [Antoine] Guillemet" (1843-1918), is accepted by the Salon. That September, he visits Zola in Médan, then Choquet in Hattenville, Normandy, and finally Pissarro in Pontoise. Spends October in Aix.

1883

Lives from May to December in Aix and L'Estaque; is visited there, in December, by Claude Monet (1840-1926) and Renoir, with whom he goes to La Roche-Guyon on the Seine, twenty-five miles northwest of Paris.

1884

Spends most of his time in Aix and L'Estaque.

1885

Involved in a mysterious love affair in Aix, Cézanne leaves to spend June and July with Renoir in La Roche-Guyon. He then goes to Villenes, near Pointoise, and Vernon, near Giverny. Visits Zola in Médan. Spends the autumn and winter in Gardanne, south of Aix.

Cézanne's studio on the Chemin des Lauves with coat rack and still life objects, ca. 1930

Cézanne's paint box, palette, and umbrella

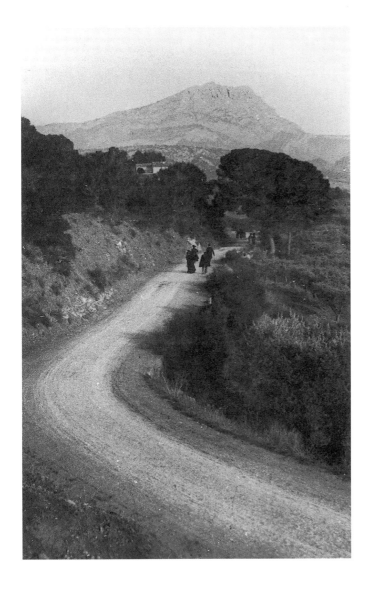

Mont Sainte-Victoire
seen from the road to
Le Tholonet, ca. 1900

1886

Lives in Gardanne, spending February in Paris.
In March, Zola's novel *L'Œuvre* is published, de-
scribing an unsuccessful artist in whom Cézanne
recognizes himself. Offended and hurt, he breaks
with Zola. April 28: Marries Hortense Fiquet.
Spends the summer in Paris, then stays with
Chocquet in Hattenville. October 23: Cézanne's
father dies, leaving him a considerable inheri-
tance.

1887

Sojourn in Aix. Exhibits in Brussels with the
Les XX group.

1888

In January, paints with Renoir in L'Estaque and
Aix, then returns to his Paris studio at 15, quai
d'Anjou. Cézanne works in the environs of Paris,
at Chantilly, Créteil, Eragny, and Alfort.

The Jas de Bouffan,
the Cézannes' country residence,
seen from the garden, ca. 1930

Below:
Cézanne seated before one
of his *Bathers*, ca. 1904

1889
In June, visits Chocquet in Hattenville. Spends the summer and the following months primarily in Aix. Renoir visits him for several months and they paint together.

1890
Shows three paintings in the exhibition of *Les XX* in Brussels. Moves to avenue d'Orleans in Paris. Spends the summer with his family, in French Switzerland, then returns to Aix. Symptoms of diabetes begin to appear.

1891
Cézanne lives with his mother at the Jas de Bouffan, having installed his family in Aix. Journeys to Paris and Fontainebleau. He becomes a practicing Catholic.

1892
Divides his time between Aix and Paris, where he resides at 2, rue des Lions-Saint-Paul. Paints in the forest of Fontainebleau and buys a house in the nearby village of Marlotte.

1893
Sojourns in Aix, Paris, and Marlotte.

1894
Works in Avon, Barbizon, and Mennecy. Spends time in the spring in Alfortville and visits Monet at Giverny in the autumn.

1895
Spends January to June in Paris, living on rue Bonaparte, before returning in June to Aix. November to mid-December: Cézanne's first solo exhibition is held at the gallery of art dealer Ambroise Vollard (1865-1939).

Cézanne painting
"sur le motif"
on the hill
of Les Lauves, 1905

1896
After a rest-cure in Vichy in June, Cézanne spends July and August in Talloires, on Lac d'Annency, in the Savoy Alps. Returns to Paris in September, living on rue des Dames.

1897
Moves his Paris residence to 73, rue Saint-Lazare. Spends May in Mennecy and returns to Aix in June. Works a great deal outdoors, in Le Tholonet and the Bibémus quarry. October 25: Cézanne's mother dies.

1898
Spends the first part of the year in Aix, making excursions to Montgéroult, Seine-et-Oise, Marines near Pontoise, Marlotte, and Montigny-sur-Loing. Lives in Paris, at 5, rue Hégésippe-Moreau, from summer to the end of the year; this will be his last lengthy sojourn in the capital.

1899
Returns to Aix in the autumn. November 25: The Jas de Bouffan is sold. Two of Cézanne's works are auctioned—his first financial success.

1900
Three of his paintings are shown at the Paris Century Exhibition held during the World Fair.

1901
November 18: Cézanne buys a lot on Chemin des Lauves, north of Aix.

1902
Studio building on Chemin des Lauves, designed by local architect M. Morgues, is completed in September. In the autumn, Cézanne travels in the Cévenne mountains, west of the Rhone River. In his last will and testament, he makes his son, Paul, his sole heir. September 29: Zola dies in Paris. When he hears of it, Cézanne is deeply moved.

1904
From March to April, is visited in Aix by the young painter Emile Bernard (1868-1941). Represented with thirty paintings in the Salon d'Automne, Cézanne travels to Paris and paints in the vicinity of Fontainebleau.

Cézanne on the hill of Les Lauves, 1905

1905
Works that summer in the forest of Fontainebleau. Maurice Denis (1870-1943) and Emile Bernard visit him in March.

1906
In January, Cézanne is visited in Aix by Maurice Denis and Ker-Xavier Roussel (1867-1944). In the summer, suffers an attack of bronchitis. October 22: Paul Cézanne dies in Aix.

1907
Large commemorative exhibition, comprising 56 paintings, held in Paris at the Salon d'Automne. Cézanne is recognized as "the father of modern art."

Notes

1 Joachim Gasquet, in a review of Charles de Ribbe's book *La Société provençale à la fin du moyen-âge*, in *Les Mois dorés* (March-April 1898).

2 Cézanne to Henri Gasquet, Dec. 23, 1898; *Paul Cézanne: Letters*, ed. John Rewald, trans. Marguerite Kay (rev. ed., Oxford, 1976), p. 267.

3 Cézanne to Victor Chocquet, May 11, 1886; ibid., p. 225.

4 Ibid.

5 Verse in a letter to Emile Zola, July 9, 1858; ibid., p. 27.

6 Emile Zola, *The Masterpiece*, trans. Thomas Walton, rev. Roger Peardon (Oxford, 1993), pp. 34-39.

7 Zola to Baille, Feb. 20, 1860; *Letters* (note 2), p. 49.

8 Quoted in Christoph Wetzel, *Paul Cézanne: Leben und Werk* (Stuttgart and Zurich, 1984), p. 9. *The Conquest of Plassans* (1874) is the fourth of the twenty novels in the series *Les Rougon-Macquart*.

9 Zola, *The Fortune of the Rougons* (London, 1886), pp. 40-42.

10 Ibid., p. 77.

11 Verse in a letter to Zola, Dec. 7, 1858; *Letters* (note 2), p. 33.

12 Cézanne to Joseph Huot, June 4, 1861; *Letters* (note 2), p. 85.

13 Cézanne to Zola, Oct. 1866; ibid., pp. 112-13.

14 Zola, *My Hatreds*, trans. Palomba Paves-Yashinsky and Jack Yashinsky (Lampeter, 1991), p. 150. The original reads: "J'exprimerai toute ma pensée en disant qu'une œuvre d'art est un coin de la création vu à travers un tempérament."

15 Cézanne to Pissarro, Oct. 23, 1866; *Letters* (note 2), p. 114.

16 Cézanne to his parents, 1874; *Letters* (note 2), pp. 138-39.

17 Cézanne to Zola, March 23, 1878; ibid., p. 154.

18 Cézanne to Zola, March 28, 1878; ibid., p. 155.

19 Ambroise Vollard, *Paul Cézanne* (Paris, 1914), pp. 31-33.

20 The following interpretation is based on that given by Hajo Düchting in his *Paul Cézanne: Natur und Kunst* (Cologne, 1990), pp. 58-62.

21 On Cézanne and Impressionism, see ibid., p. 75.

22 Cézanne to Zola, Sept. 24, 1878; *Letters* (note 2), p. 169.

23 Cézanne to Pissarro, July 2, 1876; ibid., p. 146.

24 See the "glossary of figures" in Mary Louise Krumrine (ed.), *Paul Cézanne: The Bathers* (London, 1990), pp. 244-53.

25 See ibid. for a detailed analysis of the "Bathers" series.

26 Profoundly influenced by Cézanne in their development of Cubism, Pablo Picasso and Georges Braque extended, and later perfected, his technique of simultaneously depicting objects from more than one viewpoint. The reader is referred to studies on Cubism, among the best of which are Pierre Daix, *Journal du Cubisme* (Geneva, 1982); Robert Rosenblum, *Cubism and Twentieth-Century Art* (New York, 1976); and William Rubin (ed.), *Picasso and Braque: Pioneering Cubism*, exhibition catalogue (New York: Museum of Modern Art, 1989).

27 *Joachim Gasquet's Cézanne*, trans. Christopher Pemberton (London, 1991), p. 150.

28 Quoted in Léo Larguier, *Le Dimanche avec Paul Cézanne* (Paris, 1925), p. 138.

29 Quoted in John Rewald, *Cézanne: A Biography* (New York, 1986), p. 93.

30 Cézanne to Zola, Dec. 19, 1878; *Letters* (note 2), p. 173.

31 See the publications cited in note 26.

32 Cézanne to Emile Bernard, April 15, 1904; *Letters* (note 2), p. 301.

33 Cézanne to Zola, May 24, 1883; ibid., p. 196.

34 Cézanne to Paulette Conil, Sept. 1, 1902; ibid., p. 292.

35 Cézanne to Philippe Solari, July 23, 1896; ibid., pp. 251-52.

36 Jules Borély, "Cézanne à Aix," *Conversations avec Cézanne* (Paris, 1978), pp. 21-22.

37 Cézanne to Emile Bernard, 1905; *Letters* (note 2), p. 315.

38 See Rewald (note 29), pp. 241-45.

39 Joachim Gasquet, in the journal *Les Mois dorés* (1896).

40 Cézanne to Emile Bernard, Oct. 23, 1905; *Letters* (note 2), pp. 316-17.

41 Emile Bernard, *Souvenirs de Cézanne et lettres*, 4th ed. (Paris, 1924), pp. 29-30.

42 *Joachim Gasquet's Cézanne* (note 27), p. 148.

43 Ibid., p. 153.

44 Cézanne to Paul Cézanne Jr., Oct. 13, 1906; *Letters* (note 2), p. 335.

Selected Bibliography

Adriani, Götz. *Paul Cézanne: Zeichnungen.* Cologne, 1978.
———. *Paul Cézanne: Aquarelle.* Exhibition catalogue. Kunsthalle, Tübingen, and Kunsthaus, Zurich, 1982. Cologne, 1981. English ed.: *Paul Cézanne: Watercolors.* New York, 1983.
———. *Paul Cézanne: Gemälde.* Exhibition catalogue. Kunsthalle, Tübingen. Cologne, 1993.
Arrouye, Jean. *La Provence de Cézanne.* Aix-en-Provence, 1982.
Badt, Kurt. *Die Kunst Cézannes.* Munich, 1956. English ed.: *The Art of Cézanne*, trans. Sheila Ann Ogilvie. London and Berkeley, 1965; 2nd ed. New York, 1985.
———. *Das Spätwerk Cézannes.* Constance, 1971.
Beucken, Jean de. *Un Portrait de Cézanne.* Paris, 1955. English ed.: *Cézanne*, trans. Lothian Small. London, 1962.
Boehm, Gottfried. *Paul Cézanne: Montagne Sainte-Victoire.* Frankfurt am Main and Munich, 1988.
Brion, Marcel. *Paul Cézanne.* Milan, 1971; 2nd ed. 1972. English ed.: *Paul Cézanne.* London, 1974; repr. 1988.
Cézanne, Paul. *Paul Cézanne: Correspondance.* Ed. John Rewald. Paris, 1937; rev. ed. 1978. English ed.: *Paul Cézanne: Letters*, trans. Marguerite Kay. London, 1941; 4th rev. ed. Oxford, 1976.
Cézanne: The Late Work. Ed. John Rewald, William Rubin et al. Exhibition catalogue. Museum of Modern Art, New York; Museum of Fine Arts, Houston; and Grand Palais, Paris, 1977-78. New York, 1977.
Cézanne: The Early Years, 1859-1872. Ed. Lawrence Gowing et al. Exhibition catalogue. Royal Academy of Arts, London; Musée d'Orsay, Paris; and National Gallery of Art, Washington, D.C. , 1988-89. London, 1988.
Chappuis, Adrien. *The Drawings of Paul Cézanne: A Catalogue Raisonné.* 2 vols. Greenwich, Conn., 1973.
Doran, Michael. *Conversations avec Cézanne.* Paris, 1978; 2nd ed. 1981.
Dorival, Bernard. *Cézanne.* Paris, 1948.
Düchting, Hajo. *Paul Cézanne, 1839-1906: Natur und Kunst.* Cologne, 1990.
Elgar, Frank. *Cézanne.* Paris, 1968. English ed.: *Cézanne.* London and New York, 1969; repr. New York, 1975.
Fry, Roger. *Cézanne: A Study of His Development.* London and New York, 1927; 2nd ed. London, 1952.
Gasquet, Joachim. *Cézanne.* Paris, 1921; 2nd ed. 1926; repr. Grenoble, 1988. English ed.: *Joachim Gasquet's Cézanne*, trans. Christopher Pemberton. London, 1991.
Kendall, Richard. *Cézanne by Himself: Drawings, Paintings, Writings.* London, 1988.
Novotny, Fritz. *Cézanne und das Ende der wissenschaftlichen Perspektive.* Vienna, 1938; 2nd ed. Vienna and Munich, 1970.
Perruchot, Henri. *La Vie de Cézanne.* Paris, 1956.
Rewald, John. *Cézanne: Sa Vie, son œuvre, son amitié pour Zola.* Paris, 1939. English ed.: *Cézanne: A Biography.* New York, 1939.
———. *Cézanne: A Biography.* New York, 1986.
———. *Paul Cézanne: The Watercolors.* Boston and London, 1983.
Rilke, Rainer Maria. *Briefe über Cézanne.* Ed. Clara Rilke. Wiesbaden, 1952; repr. Frankfurt am Main, 1983. English ed.: *Rilke: Letters on Cézanne*, trans. Joel Agee. New York, 1985; 3rd ed. London and New York, 1991.
Schapiro, Meyer. *Paul Cézanne.* New York, 1952; 2nd ed. 1986.
Shiff, Richard. *Cézanne and the End of Impressionism.* Chicago and London, 1984.
Venturi, Lionello. *Cézanne: Son Art, son œuvre.* Catalogue raisonné. 2 vols. Paris, 1936; 2nd ed. San Francisco, 1989.
———. *Cézanne.* Geneva, 1978. English ed.: *Cézanne.* London, 1978.
Vollard, Ambroise. *Paul Cézanne.* Paris, 1914; 2nd ed. 1919. English ed.: *Paul Cézanne: His Life and Art*, trans. Harold L. Van Doren. New York, 1923, and London, 1924; 2nd ed. New York, 1927; 3rd ed. New York, 1937.
Wetzel, Christoph. *Paul Cézanne: Leben und Werk.* Stuttgart and Zurich, 1984.
Zola, Emile. *L'Œuvre.* Vol. 15 of *Les Rougon-Macquart.* Paris, 1886. English ed.: *The Masterpiece*, trans. Thomas Walton, rev. Roger Pearson. Oxford, 1993.

List of Illustrations

The Cabanon de Jourdan 1906
Oil on canvas
25 ⅝ x 32 in. (65 x 81 cm)
Galleria Nazionale d'Arte Moderna,
Rome
page 100

*Self-Portrait with Turquoise
Background* ca. 1885
Oil on canvas
21 ¾ x 18 ¼ in. (55.1 x 46.4 cm)
The Carnegie Museum of Art,
Pittsburgh
page 102

*Madame Cézanne in the
Conservatory* 1891 - 92
Oil on canvas
36 ¼ x 28 ¾ in. (92 x 73 cm)
The Metropolitan Museum of Art,
New York, Collection Stephan C.
Clark
page 103

Marie Cézanne, one of the
artist's sisters ca. 1870
page 104

Paul Cézanne with Camille
Pissarro near Auvers,
ca. 1874

Paul Cézanne with Camille
Pissarro and friends in Pontoise
1877
page 105

Cézanne in his studio on the
Chemin des Lauves 1894
page 106

Cézanne's studio on the
Chemin des Lauves ca. 1904
page 106

Cézanne's paint box, palette,
and umbrella
Photo: Malch
page 107

Cézanne's studio on the
Chemin des Lauves with coat
rack and still life objects
ca. 1930
page 107

Mont Sainte-Victoire seen
from the road to Le Tholonet
ca. 1900
page 108

The Jas de Bouffan seen from
the garden ca. 1930
page 109

Cézanne seated before one of
his *Bathers* ca. 1904
Photograph taken in the studio on
the Chemin des Lauves by Emile
Bernard
page 109

Cézanne on the hill of
Les Lauves 1905
Photo: Emile Bernard
page 110

Cézanne on the hill of
Les Lauves 1905
Photo: Emile Bernard
page 111

Photograph Credits